W9-AFD-717

The Middle Ages

ANNE SHAVER-CRANDELL

CAMBRIDGE UNIVERSITY PRESS
Cambridge
New York New Rochelle
Melbourne Sydney

Published by the Press Syndicate of the University of Cambridge
The Pitt Building, Trumpington Street, Cambridge CB2 1RP
32 East 57th Street, New York, NY 10022, USA
10 Stamford Road, Oakleigh, Melbourne 3166, Australia

First published 1982
Reprinted 1988

Printed in Hong Kong by Wing King Tong

Library of Congress catalogue card number: 81-9989

British Library cataloguing in publication data

Shaver-Crandell, Anne

The Middle Ages – (Cambridge introduction to the history of art; 2)
1. Art, Medieval – Europe
I. Title
709'.02 N5970
ISBN 0 521 23209 0 hard covers
ISBN 0 521 29870 9 paperback

Acknowledgements

For permission to reproduce illustrations the author and publisher wish to thank
the institutions mentioned in the captions. The following are also gratefully
acknowledged:
p.1 Courtauld Institute of Art; pp.2 (above), 22 Fotografie della Societa Scala,
Florence; p.6 La Documentation Française, © by Yan-tourisme; pp.8, 14, 24, 28
(right), 36, 78 (below left, Martin-Sabon; below right, J. Feuille), 79 (J. Feuille),
105, 106 (Lefevre-Pontalis) © Arch. Phot. Paris/SPADEM; pp.11, 27, 32, 61,
67, 74, 75, 95, 104, 107 The Mansell Collection; pp.12, 13, 15, 17, 19, 20, 21, 33,
38, 39, 43, 44, 46, 66, 68, 70, 71, 72, 73, 77, 78 (above) © James Austin; pp.18, 28
(left), 40, 41, 50 Anne Shaver-Crandell; pp.10, 23, 30, 103 Ampliaciones y
Reproducciones MAS; pp.25, 29, 49, 59, 81, 82, 83, 97, 98, 101, 102 Royal
Commission on Historical Monuments, Crown Copyright; p.34 reproduced by
courtesy of the Trustees of the British Museum; p.37 Peter Foster; p.47 French
Government Tourist Office; pp.52, 53 Foto Wladimir Narbutt-Lieven; pp.56, 64,
65 Photographie Giraudon; pp.84, 85, 99, 100 Bildarchiv Foto Marburg; p.92
Helga Schmidt-Glassner; p.109 Cliché des Musées Nationaux, Paris.
Map by Ron Jones, diagrams by Oxford Illustrators Ltd

Contents

Contents

Introduction

This book is about the art and architecture of Western Europe from the second half of the eleventh century to the end of the fourteenth century. The art and architecture of the early part of this period is called by the style-name Romanesque. It laid the groundwork for the creations of the better-known later style, called the Gothic.

Of course to imply that Romanesque art began around 1050 is to make an artificial division. Art is created by artists and craftsmen who fashion beautiful things for those who want and can afford them. This activity had been going on in Western Europe from the time of the Greeks and Romans, and all through the centuries known as the Dark Ages.

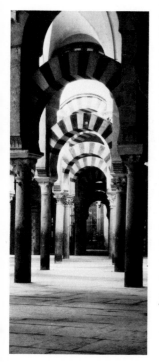

Double arches inside the mosque, now cathedral, Córdoba, Spain, 8th century

The patrons were usually rulers, of Church or state. Emperor Justinian, for example, had himself and some of his courtiers portrayed in gleaming mosaic on the wall of the church of San Vitale in Ravenna. In AD 785 the Muslim ruler of Córdoba in Spain, Abd al-Rahman, began the building of a great mosque, combining Islamic decoration with a system of arches probably derived from Roman aqueducts. The intricate manuscript decorations made by Irish monks and the so-called Alfred Jewel are famous masterpieces from these 'Dark' years, and there were many others, especially works of monastic art. Taking their inspiration from the founder of monasticism, St Benedict (480–c. 550), monasteries spread all over Europe. They were centres of art and learning, producing many beautiful things. They preserved the best of the cultural traditions of the ancient world and adapted or assimilated new styles from the peoples moving into Europe from north and east. A whole study of the works of art produced in those turbulent times would be needed to understand the origins of medieval art, and these examples can indicate only a few trends.

To understand fully the art and architecture of the Middle Ages, we also need to know something of medieval life and to be familiar with medieval building procedures and image-making techniques,

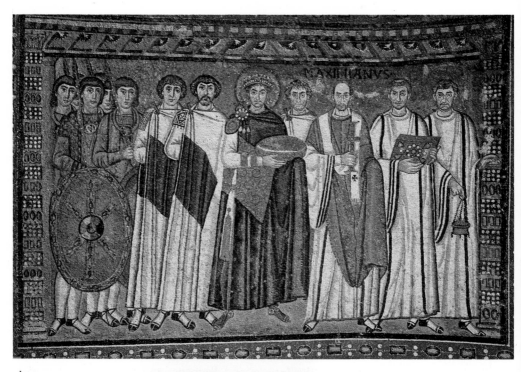

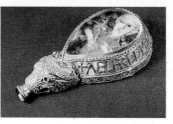

as well as the subjects of the images. People today, accustomed to austere, undecorated modern buildings, freestanding sculptures and framed easel paintings hanging on walls, are sometimes puzzled by the fact that many Romanesque and Gothic monuments are groups of images attached to the insides or outsides of buildings. Therefore, one purpose of this book is to help the reader to understand medieval building types, styles and methods. Another purpose is to explain some of the physical materials and techniques used in making medieval images. As for subject matter, most of the works to be discussed were made for the Roman Catholic Church. Since its teachings and goals are no longer so universally familiar as they were in the Middle Ages, this book will also give some keys to medieval iconography – the study of subject matter, as distinct from the analysis of style.

2

1 Romanesque architecture and art

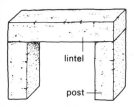

The post-and-lintel system.

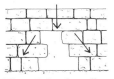

The weight of a wall thrusts downwards. If some blocks are removed the others still support one another and carry the thrust outwards and downwards.

The hole can be made neater, and wedge-shaped blocks (voussoirs) fitted to hold one another together at the top of the hole. They need to be supported by a wooden frame, which is removed when the arch is complete.

The name Romanesque is a nineteenth-century invention meaning 'Roman-like'. The term was originally used in speaking of architecture and refers to the resemblance of the typical buildings of the late eleventh and twelfth centuries in Europe to the thick-walled, vaulted masonry structures of the ancient Romans.

The most characteristic feature of Romanesque architecture is its use of vaulting. Vaulting means the covering of spaces with curved roofs made of masonry, as opposed to spanning openings with horizontal beams resting on columns or jambs. This latter arrangement is sometimes called the post-and-lintel system. The structural basis of vaulting is called the arch-and-pier system. A pier is a free-standing solid masonry support. An arch, from which a vault grows, is a structural member composed of a series of wedge-shaped blocks, called voussoirs, that is used to span an opening. Since an arch can span a wider opening than a simple lintel, the builder may use fewer supports within a structure that is vaulted. Christian builders deemed this a great advantage, for they had to build church interiors with as few internal obstructions as possible. Much of Christian worship is communal, and the congregation needed to see the priest who led them in prayer.

Another advantage of vaulted construction was fireproofing. Most of the church architecture of the Early Christian, Carolingian and Ottonian periods that preceded the Romanesque was timber-roofed, because wood was plentiful in Europe and such buildings were relatively simple to construct. But medieval chronicles are full of tragic accounts of fires that devastated those timber-roofed churches. When people tired of seeing their churches burn, they began to learn to build masonry vaults.

The simplest vault is an arch extended sideways. This is a barrel or tunnel vault. Since this kind of covering is very heavy and allows little light into an interior, builders in ancient Rome had evolved the groin vault. This consists of two barrel vaults intersecting each other

3

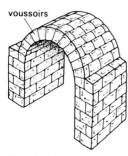

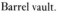

Barrel vault.

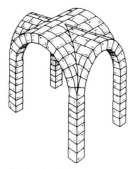

Groined vault.

at right angles to form a canopy on four piers. The seams along which the two barrel vaults are joined are called groins. Though it is difficult to construct a groin vault above a plan that is any shape other than a square, this more open form is desirable because it allows much more light to enter a building.

These two forms, the barrel vault and the groin vault, were used in almost all Romanesque churches. Visually, these vaults give the impression of solidity, calm, repose – a lack of striving. Their surfaces are smooth, the semicircular lines returning our eyes to the floor after each sweep through space.

Also characteristic of the Romanesque style are the massive piers that support the vaults and the thick, smooth masonry walls, with splayed openings for little windows.

ST-SERNIN, TOULOUSE: A 'PILGRIMAGE ROAD' CHURCH

We can get a better idea of Romanesque architecture if we look at a specific building, the church of St-Sernin in the southwestern French city of Toulouse, ancient capital of the region of Languedoc. St-Sernin is an example of what we sometimes call the 'Pilgrimage Road' type of Romanesque church, which was designed in part to solve a traffic problem.

During the Middle Ages, just as now, people travelled on pilgrimages to holy places, sometimes in the hope of being cured of a disease, sometimes as an alternative to prison because of a misdeed committed at home, sometimes because the Catholic Church promised eternal salvation for the souls of pilgrims. Apart from the medical, legal and spiritual benefits, pilgrimage offered one of the relatively few opportunities for travel available at that time to ordinary people. Even women could go on pilgrimages, which were often like conducted group tours. The most prestigious goals of Christian pilgrimage were Jerusalem, where Jesus Christ had lived and died; Rome, site of the martyrdom of the first pope, St Peter, and administrative centre of the Church; and Santiago de Compostela in northwestern Spain, where the apostle James (Iago in Spanish) was believed to be buried.

By the tenth century, people began to stream across France and

4

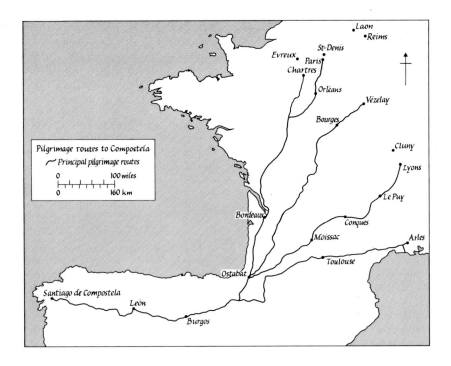

Spain to visit the shrine of St James. In the twelfth century, there was even a guidebook that advised travellers of the best routes to follow, the location of particularly effective holy relics, the purity of local water supplies, and the unpleasant habits of the natives encountered along the way. As traffic along these recommended routes increased with the rising popularity of the Compostela pilgrimage, local churches began to experience problems all too familiar in modern times to people who live near sites that other people want to visit – interference with the flow of daily life in the towns and buildings normally used only by local people. Many churches housed the relics of holy people. These were believed to possess miraculous healing powers. Visiting pilgrims wanted to see the exhibited relics and other precious objects kept in church treasuries, while local people wished to attend the normal daily services in their churches without being disturbed.

To accommodate pilgrims, who provided an important source of revenue, architects devised a ground-plan that created a continuous walkway around the periphery of a church. Visitors could walk inconspicuously along this aisle, admiring the church structure and visiting the local relics and other treasures. These could now be displayed in small chapels radiating from the curved segment of the walkway, called the ambulatory, around the altar end of the church.

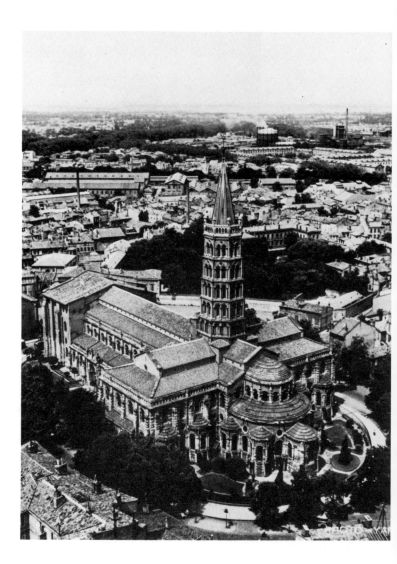

St-Sernin, Toulouse,
c. 1080–1120.
Aerial view and plan.

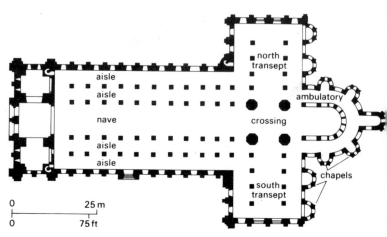

Regular services proceeded undisturbed in the taller central space of the church.

Toulouse stands squarely on one of the principal routes leading through France to Santiago de Compostela. The church of St-Sernin is a splendid example of the type of church just mentioned. Since the region around Toulouse has very little building stone, the church is constructed primarily of the local peach-coloured brick. The builders used stone only for such special details as window-openings, doorways, corner-mouldings, and sculptural decoration. The exterior view shows the cruciform layout, with a tall tower at the crossing of the two axes of the structure. This plan, which came to symbolize the body of Christ on the cross, was traditional long before the beginning of construction of St-Sernin in the late eleventh century. We can see the nave, where the congregation stood and knelt, and the transept, the transverse arm of the church. The eastern complex, the sanctuary end of the church, is called the chevet. The word means 'pillow' in French; this portion of the church was conceived of as a kind of pillow for Christ's head as he hung upon the cross. You can see clearly how the tall, principal volumes of the building are surrounded by the peripheral walkway. Above this level, and below the height of the tallest spaces, continuous galleries form an intermediate level. The building is organized in large clear masses of masonry marked off by stabilizing buttresses into structural units called bays. Each bay has its own window opening.

When we enter the building, we see the same subdivision into bays as on the outside of the building. This is characteristic of the organization of Romanesque structures. Compound piers support the main arcade, or ground storey. From each of these compound piers, half-columns rise past the arcaded galleries to the height of the barrel vault covering the nave. The galleries are vaulted with half-barrel vaults which exert counter-pressure against the outward, downward thrust of the main barrel vaults. At ground level again, the aisles and ambulatory are vaulted with groin vaults, each bay making a clearly defined box of space. These bays are related proportionately to one another. Like the famous ninth-century monastery plan from St Gall in Switzerland which for centuries provided a model for an ideal church layout, the plan of St-Sernin

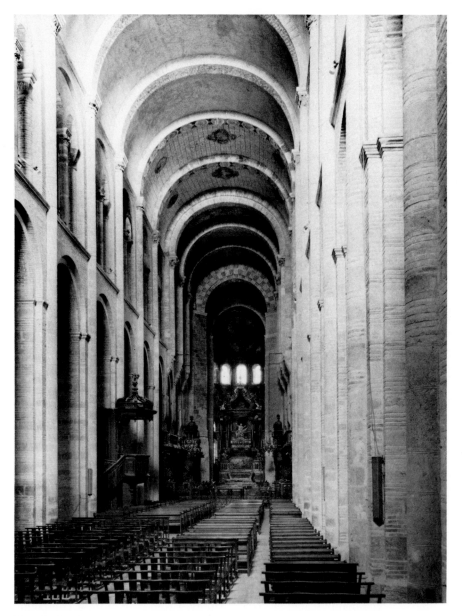

Nave, St-Sernin,
Toulouse.

depends on a module, the crossing bay. The bays of the nave are
each one-half of the size of the crossing bay. The aisle bays are each
one-fourth of the crossing bay.

The effect on the visitor is of an overwhelmingly vast, sheltering
interior space, dark and cool in contrast to the blazing sunlight
outside. This overpowering effect is enhanced by the echoing of
sounds in the extreme length of the basilica.

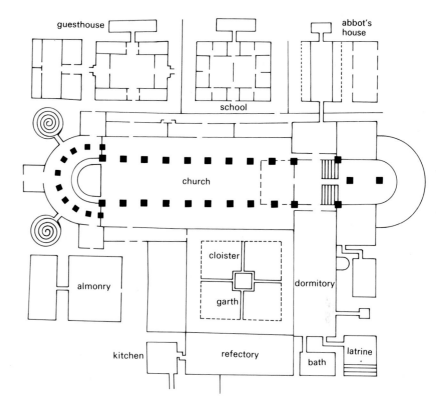

Simplified plan of the
projected monastery at
St Gall, Switzerland.

PORTE MIÈGEVILLE: THE ASCENSION OF CHRIST

At a time when very few people could read or write, the church
relied heavily on paintings and sculptures to communicate with its
members and with potential converts. Church interiors frequently
displayed paintings of religious scenes on the walls and vaults.
Sculptors made small-scale carvings on capitals, the topmost
elements of columns and piers. But the most concentrated visual
statements are seen in the sculpture of portals, even before one
enters a church.

The Porte Miègeville is the portal opening into the fifth bay of the
south aisle of the nave of St-Sernin. This doorway, probably made
about 1110, is one of the first groups of large-scale European
sculpture to be made after the fall of the Roman Empire. The
Romans were experienced at using sculpture in buildings, but the
art of monumental sculpture had been forgotten during the earlier
centuries of the Middle Ages, along with other such amenities of
Roman civilization as indoor plumbing. You can see that the general
outlines of the Porte Miègeville resemble the forms of a typical

9

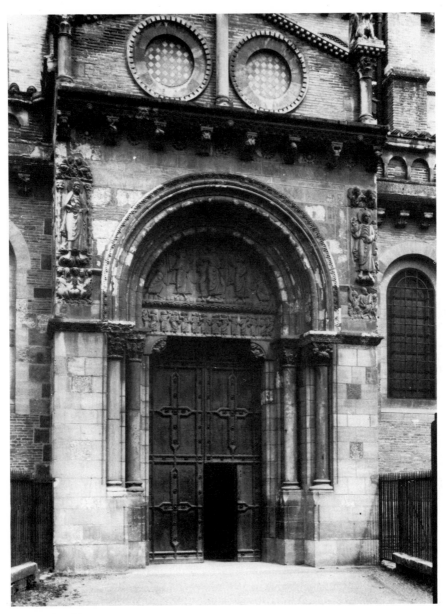

Porte Miègeville, 1110,
St-Sernin, Toulouse.

Roman triumphal arch like the one at Orange in southern France
shown here. Indeed, the medieval church portal in all periods may
be understood as a gateway to a place of victory, Christ's kingdom,
symbolized by the sanctuary within. With this in mind, we can
better understand why so much sculptural decoration was lavished
upon the Porte Miègeville.

The largest area to be decorated with sculpture, called the

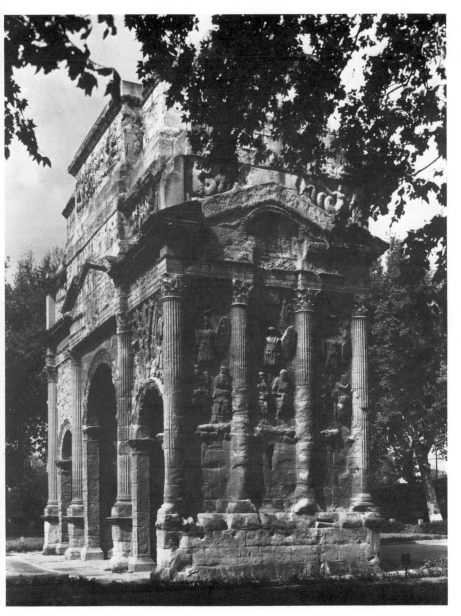

Roman triumphal arch at
Orange, probably early
1st century AD.

tympanum, is the semi-circular wall beneath the heavy arches
framing the doorway. The tympanum represents the biblical
description of the Ascension of Christ, his departure for heaven
after his resurrection from death. The central figure is Christ
himself with arms raised, his upward progress aided by two angels.
At either side, pairs of angels holding crosses frame the central
group with their saluting bodies. In the lintel, the beam supporting

11

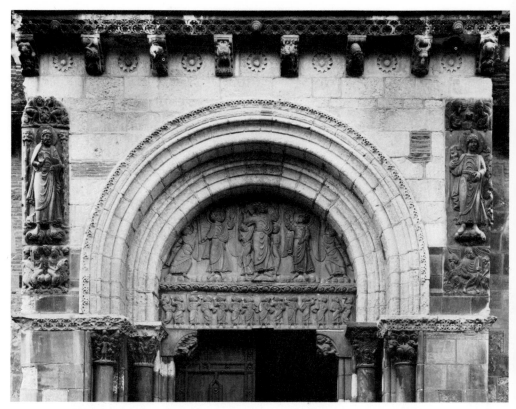

Ascension of Christ,
tympanum, Porte
Miègeville, St-Sernin,
Toulouse.

the tympanum, two more angels address the rather bewildered
apostles who are watching their beloved master ascend to his Father
in heaven.

Like most Romanesque depictions of religious events, the
composition is very symmetrical, its balance emphasizing the
solemnity of the occasion. The posed, idealized individual figures
reveal the sculptor's familiarity with Roman sculpture. Yet the
arbitrary flattening and shortening of the apostle-figures in order to
fit them neatly on to the lintel indicate a new attitude on the part of
the artist. He seems to care less for ideally beautiful proportions
than for the concise presentation of a story within the space
available.

On the walls of the portal at either side of the tympanum are
carved reliefs of St Peter and St James. Peter was the first pope, and
here symbolizes the Catholic Church as an organized entity. James
is here because some of his relics were in the church of St-Sernin and
because many of the people arriving in front of the Porte Miègeville
would have been on their way to visit his shrine at Santiago de

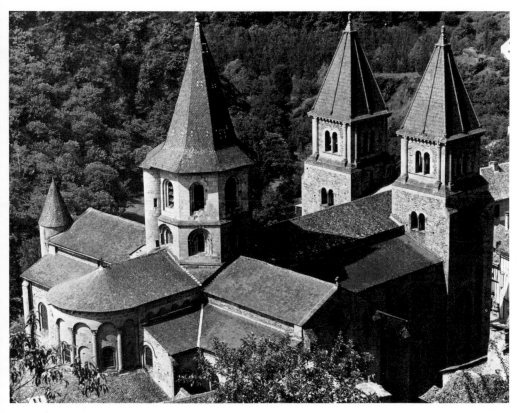

Ste-Foy, Conques, 11th
century, completed 1140.

Compostela. Both saints are depicted trampling on beasts as a sign
of their conquest of evil. We remember that Christ is shown
conquering death by ascending to heaven. The message of the Porte
Miègeville is thus the promise to humankind of redemption from sin
through belief in Christ and through following the teachings of his
church.

STE-FOY, CONQUES: A LITTLE GIRL'S SHRINE

Another of the 'Pilgrimage Road' churches is nestled in a green
valley near the middle of France at a small town called Conques. Its
church was built in honour of a little girl named Foy (the name
means 'Faith') who was put to death at the age of nine for her
Christian beliefs.

Her memory is kept alive through an extraordinary image, the
reliquary of Ste Foy, centrepiece of the treasury of the church.
Reliquaries were common in the Middle Ages. Bones or garments or

13

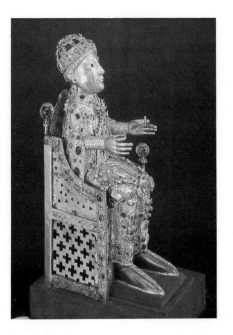

Reliquary of Ste Foy,
Treasury, Ste-Foy,
Conques.

other physical remains of holy persons were encased in boxes or
sculpture covered with gold, enamelled panels and precious gems.
Relics of Ste Foy were preserved in this seated figure, which is like a
little one-person history of medieval metalwork and gem-carving.
Ste Foy's head was a re-used Roman parade helmet, encrusted with
a crown and gems to bring it 'up to date'.

The church at Conques looks like a smaller version of St-Sernin
built in honey-coloured stone. In the middle of the west façade is a
portal with a Last Judgement tympanum dated about 1140. It
illustrates the belief that on the last day of all time, Christ will return
to earth to judge all souls who have ever lived, and to send the good
to heaven and the evil to hell for eternity. Christ sits serenely at the
centre of the tympanum inside a star-studded mandorla, a pointed
oval shape suggesting an aura of light that indicates the sanctity of
the person placed within. His right hand (our left as we look at the
image) is raised toward heaven and the blessed souls whose new
home it is to be. His left hand gestures downward toward hell and
the damned who are to go there. This linking of a person's right side
with good and his left side with evil is constant throughout medieval
art. (The Latin language may help us to remember this. The word
for 'left' is *sinister*, which has come to mean 'ominous' in English.
The Latin for 'right' is *dexter*, from which comes our word
'dexterous', meaning as skilled as most people are with their right

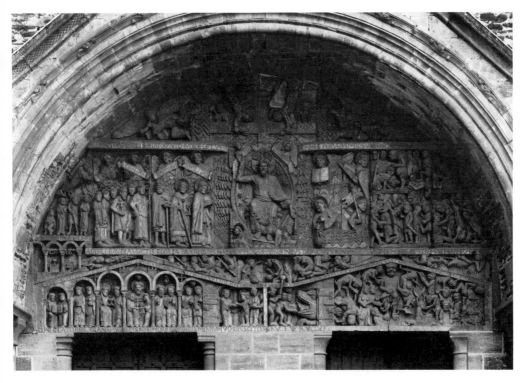

Last Judgement,
tympanum, west façade,
Ste-Foy, Conques.

hands.) The heavenly side of the tympanum seems to have posed
certain problems for the sculptors' imaginations. In heaven they
expected souls to be free of the burden of constant labour, poverty
and illness that were the lot of most people during the Middle Ages.
The representation of heaven, consequently, is characterized by
inactivity. Hell, on the other hand, was very easy to imagine, for the
sculptors must have been all too familiar with the earthly equiva-
lents of the tortures they depicted in their carvings. Physical
violence abounds. Directly beneath Christ's feet the gigantic Mouth
of Hell gobbles a hapless victim. Other devils, armed with various
weapons and an eternal supply of ill will, poke, roast, stab, beat, bind
and strangle the naked bodies of the damned. It is no wonder that
everyone feared the Day of Judgement.

Although the style of the sculpture of the Conques tympanum is
less refined than that of the Porte Miègeville, Conques offers
something else that is just as appealing: its polychromy. Polychromy
means a many-coloured coat of paint, and was a feature of almost all
medieval sculpture. The traces of colour at Conques give us a better
idea of the original appearance of a polychrome tympanum than any
other monument of the period.

15

ST-PIERRE, MOISSAC: BEAUTIFUL DEFORMITY AND DEFORMED
BEAUTY

Some days after leaving Conques, the pilgrim trudging toward
Santiago de Compostela would have come to Moissac, home of a
large and prosperous monastery, with an abbey church dedicated to
St Peter (Pierre in French).

We have seen earlier a plan of a typical monastery (page 9) that
could be used by monks setting up a new community. This would
include not only the abbey church, but also many other necessary
buildings – dormitory, refectory and washing facilities for the
monks, and places for cooking, beverage-making, animal care and
gardening. The St Gall plan even provided for the burial of monks
in a cemetery plot in which fruit-trees were to be grown. A very
important part of the monastery is the cloister, a four-sided, covered
walkway, usually built around a garden or fountain, where the
monks could walk and talk with one another. If the monastery
included a boys' school, this too was often located in the cloister.

The monks of Moissac belonged to the Cluniac order, the most
important monastic order in the Romanesque period. The order was
named after Cluny, in Burgundy, site of the mother-house of the
order. The communal life of Cluniac monks followed the
Benedictine rule, with its cultivation of the personal spiritual life
based on the Gospels, stress on the choir office, and splendour and
solemnity of worship. St Benedict had set out the main things a
Christian should do if he truly sought God. He should live in peace
with others, not always wanting his own way or having an
exaggerated idea of himself. He should live simply, not wanting to
own many things. He should pray and study the Bible.

Over the centuries increasing emphasis was placed on the
magnificence and solemnity of worship and of the buildings which
housed it. We can see in the cloister of Moissac the coming together
of available funds and the desire to use them for elaborate building
and decoration. An inscription on one of its piers records the
completion of the cloister in 1100. All around it are colonnettes
carrying capitals decorated with foliage, beasts and Bible stories. St
Bernard of Clairvaux, a twelfth-century monk of the reforming
Cistercian order who did not share the Cluniac enthusiasm for

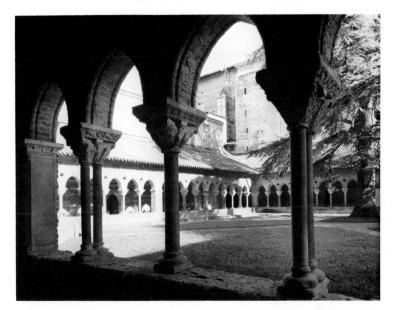

Cloisters, completed
1100, abbey of St-Pierre,
Moissac.

ornamentation, might have been thinking of this cloister when he
wrote the following complaint in a letter to William, Abbot of St
Thierry:

> But in the cloister, under the eyes of the Brethren who read
> there, what profit is there in those ridiculous monsters, in that
> marvellous and deformed comeliness, that comely deformity?
> To what purpose are those unclean apes, those fierce lions,
> those monstrous centaurs, those half-men, those striped tigers,
> those fighting knights, those hunters winding their horns?
> Many bodies are there seen under one head, or again, many
> heads to a single body. Here is a four-footed beast with a
> serpent's tail; there a fish with a beast's head. Here again the
> forepart of a horse trails half a goat behind it, or a horned beast
> bears the hinder quarters of a horse. In short, so many and so
> marvellous are the varieties of divers shapes on every hand, that
> we are more tempted to read in the marble than in our books,
> and to spend the whole day in wondering at these things rather
> than in meditating the law of God. For God's sake, if men are
> not ashamed of these follies, why at least do they not shrink
> from the expense?

We realize as we read this outburst that, like anyone today
denouncing a corrupt development in society, St Bernard was only

17

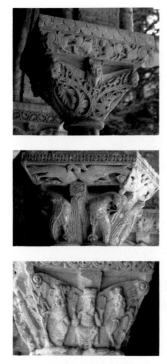

Animal capitals, and
capital showing Daniel in
the Lions' Den, cloister,
St-Pierre, Moissac.

too sensitive to the tremendous appeal of the thing about which he
protested.

As we look at typical capitals from the Moissac cloister, we can
sympathize with St Bernard's dismay about distraction from the
serious business of the monastery. One capital represents Daniel in
the Lions' Den. Daniel was a Hebrew prophet whose loyalty to God
caused him to be thrown by his enemies into a den of lions. But an
angel sent by God shut the lions' mouths, and they refused to harm
Daniel. The inspiring story of Daniel's deliverance was part of the
common Christian tradition handed down to the sculptor re-
sponsible for the capital. The story is expressed vividly in the
praying gesture of Daniel and the heraldic postures of the lions, who
show their lack of enthusiasm for eating Daniel by turning their
backs on him. The sculptor was probably illiterate, for he has had
difficulty in positioning the Latin words given him to identify
Daniel and the beasts (for example, DANIELEM CUM LEONIS –
'Daniel with the lion'). Some of the s's are carved backward, and
parts of the inscription read vertically, as though the sculptor
regarded the letters simply as decoration which had to be included
in the composition. Other Romanesque artists too seem to have
shared his view of the written word, for we often find inscriptions
used decoratively in sculptures and manuscripts. It was a style
already brought to a high degree of skill by Celtic monks, and one
which would continue throughout the Middle Ages.

Moissac also possesses one of the most dramatic of all
Romanesque portals, made about 1125. The subject of the great
tympanum is one of the most popular themes of this period: the
Apocalyptic Vision, Christ in Majesty as he appeared in a vision to
St John the Evangelist. The vision is described in the Book of
Revelation (4:3–4, 6–7) the last book of the New Testament:

There in heaven stood a throne, and on the throne sat one
whose appearance was like the gleam of jasper and cornelian;
and round the throne was a rainbow, bright as an emerald. In a
circle about this throne were twenty-four other thrones, and on
them sat twenty-four elders, robed in white and wearing crowns
of gold. . . . and in front of it stretched what seemed a sea of
glass, like a sheet of ice.

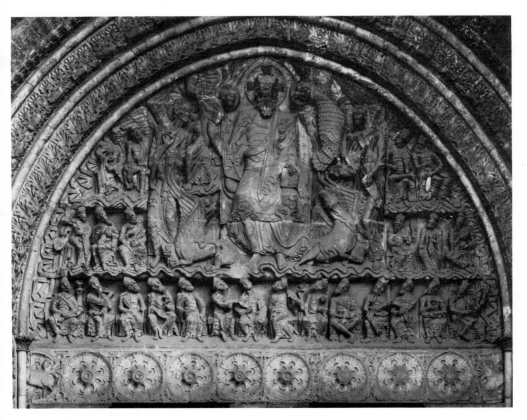

Christ in Majesty,
tympanum, south portal.
c. 1125, St-Pierre,
Moissac.

In the centre, round the throne itself, were four living
creatures, covered with eyes, in front and behind. The first
creature was like a lion, the second like an ox, the third had a
human face, the fourth was like an eagle in flight.

The sculptors who made this tympanum have shown us an awesome
figure of Christ, crowned and seated on a great throne, holding in his
left hand a book – the Word of God – and making with his right hand
a gesture called the apostolic blessing. The expression on Christ's
face is one calculated to strike fear into the hearts of those standing in
the presence of God in Majesty. Around the throne are the twenty-
four elders described in the text, each with a musical instrument.
The intention of the sculptors was to represent the elders in a circle,
but because of the conventions of Romanesque style, which did not
allow the sculptors to suggest a convincing illusion of depth by
making some of the figures smaller or by overlapping them, the
elders are simply arranged in superimposed rows that give the
composition a two-dimensional look. The angular movements of the

Jeremiah, trumeau
figure, south portal,
c. 1125, St-Pierre,
Moissac.

arms, legs and necks of the elders suggest the spiritual intensity of their contemplation of the solemn vision of eternal majesty appearing in their midst.

The four beasts – the angel, the lion, the ox and the eagle – were regarded as symbols for the four evangelists, the authors of the four Gospels. The sculptors did best with the angel of St Matthew and with the ox of St Luke, for oxen and men were readily available as models. But the scale-covered eagle of St John resembles an armadillo, and the lion symbolizing St Mark reminds some people of a frog. Clearly the artist had never seen either a lion or an eagle, so he had to imagine these creatures. His inventions are very characteristic of the Romanesque period, for he has compartmentalized their shapes, reducing the various parts of the creatures' bodies to small units instead of trying to describe the organic relationships of body parts.

Since the tympanum is so large (5.68 metres (18 ft 8 in) in diameter) that a single stone lintel was insufficient to support it, the builders put a central doorpost, called a trumeau, in the middle of the doorway opening. On the righthand side of the trumeau stands an astonishingly beautiful figure of a long-haired, barefoot prophet holding a scroll in his hands. Like the jambs at either side of the doorway, the trumeau is cusped, or scalloped. The prophet, sometimes identified as Jeremiah, nestles his head with its luxuriantly flowing moustache and beard under one of the cusps. Jeremiah's hip rests against the next cusp down, his crossed knees against another, and his feet against the bottom cusp. Thus his elongated body seems confined by the architectural form, the trumeau. This disregard for normal physical proportions and emphasis on spiritual qualities are typical of the art of this period.

LA MADELEINE, VÉZELAY : THE GIFT OF TONGUES

Another fine Romanesque tympanum belongs to the church of La Madeleine (St Mary Magdalene) at Vézelay, a little town in Burgundy very close to Cluny. Vézelay was one of the mustering points for northern European pilgrims setting out for Santiago de Compostela. The inhabitants of the valley of Vézelay must have

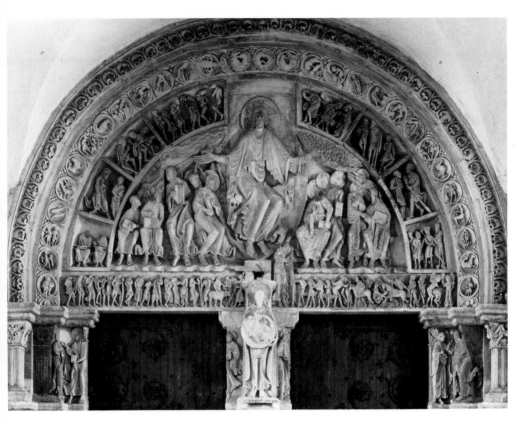

The Commission of the
Apostles, tympanum,
1120–30, west façade, La
Madeleine, Vézelay.

been especially aware of the customs of far-distant peoples. The
principal subject of the tympanum of La Madeleine, sculpted
around 1120–30, is the Commission of the Apostles. God sent his
spirit giving the apostles the 'gift of tongues' – the ability to speak
languages previously unknown to them – so that they might preach
Christianity in all the corners of the earth. A gigantic figure of
Christ, clothed in voluminous, swirling draperies, visually flattened
according to Romanesque convention, sits inside a mandorla. His
arms are outstretched and his knees turned toward our right. From
his hands issue rays of light, symbolic of divine enlightenment.
Christ is surrounded by his apostles, the recipients of God's gift of
language. At the edge of the tympanum in little compartments we
see an odd assortment of peoples from distant parts of the world to
whom the Gospel was to be carried: for example, pygmies climbing
ladders and Scythians with big ears. Framing the tympanum is an
archivolt, a decorative arch, that contains little roundels represent-
ing the twelve signs of the zodiac and an equal number of little
human figures engaged in seasonal activities, called the 'Labours of

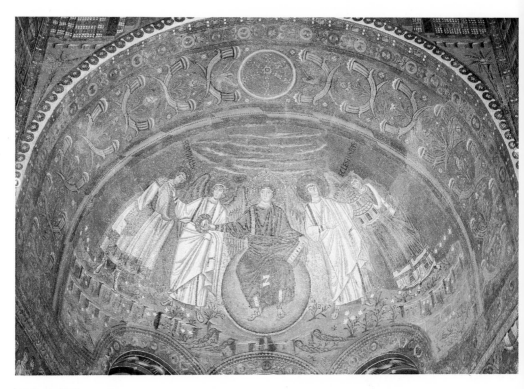

Christ in Majesty, apse
mosaic, San Vitale,
Ravenna, completed 547.

the Months'. These subjects in the archivolt suggest further the idea
of universality of the Church in both earthly and heavenly realms. It
seems particularly appropriate that in 1146 St Bernard of Clairvaux
preached here at Vézelay the Second Crusade to regain the Holy
Land from the heathen.

S. CLEMENTE, TAULL: A PAINTED CHRIST

Not all monumental Romanesque art is sculpture. The planners of
some churches preferred to concentrate the decorations of buildings
in their interiors, and the large, smooth walls and vaults of
Romanesque architecture certainly invited embellishment.

The idea of putting a large-scale image in the apse – the
semicylindrical niche surmounted by a half-dome usually found at
the altar end of the church – came from the Byzantine churches of
eastern Europe. There, the medium used was frequently mosaic,
little cubes of coloured glass set into cement. In the sixth-century
apse mosaic of Christ in Majesty in the church of San Vitale in
Ravenna in northern Italy reflections from bits of gold leaf placed

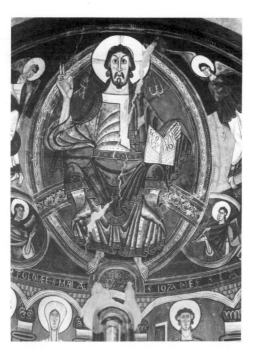

Christ in Majesty, apse fresco from S. Clemente, Taull, before 1123, Museum of Catalonian Art, Barcelona.

behind the translucent glass cubes contribute to the brilliance of the image, but also, unfortunately, to the expense of the decoration. Sometimes the planners of small churches with modest incomes substituted fresco, painting done on plastered surfaces while they are still wet (from the Italian *fresco*, meaning 'fresh'). Artists imitated as well as they could in this medium the colour effects of mosaics, relying often on crisply outlined shapes, unexpected colour contrasts, and large expanses of brilliant white background.

Another Christ in Majesty was made before 1123 for the Romanesque church of S. Clemente at Taull in Catalonia in northeastern Spain. Since the subject matter is the same, it is interesting to compare this apse fresco with the tympanum of St-Pierre at Moissac. First of all, the surfaces are dissimilar. The half-dome of the apse is curved, of course, while the tympanum is flat. The fresco defines shapes through colour and line, giving only the illusion of three-dimensionality. The relief sculpture of the tympanum is actually three-dimensional, and was, as with all Romanesque tympana, painted in bright colours. The iconography, too, is slightly different. In the fresco from Taull, the four evangelist symbols are set in a register of their own at Christ's feet, while angels fly above them. The twenty-four elders are omitted, and some of the apostles and the Virgin Mary, Christ's mother, are substituted at a

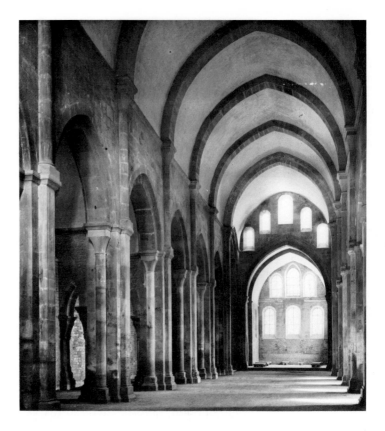

Fontenay Abbey,
1139–47.

level below Christ's feet. The painter of the fresco has included
more inscriptions than did the sculptors of Moissac. Thus, different
artists, probably acting on instructions from their local clergy,
interpreted similar Christian subjects in different ways.

FONTENAY ABBEY: CISTERCIAN ASCETICISM

Not all Romanesque buildings were so elaborately ornamented as
those seen at Toulouse, Conques, Moissac or Vézelay. St Bernard's
monastic order, called the Cistercians after Cîteaux, their mother-
house in Burgundy, was strongly opposed to decoration of any kind.
The simplicity of Cistercian architecture allows us to see which
elements of a building's design were considered structurally
necessary, rather than ornamental. In the abbey church of
Fontenay, built 1139–47, we see a slightly pointed barrel vault with
transverse arches, crisp-edged piers, simple capitals, and small
windows, but no decorative painting or sculpture.

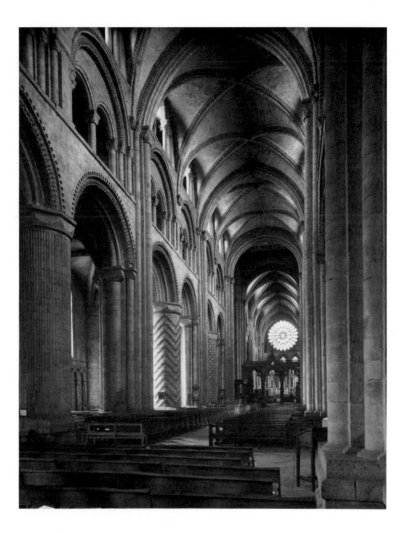

Nave, Durham
Cathedral, 1093–1133.

DURHAM: A MASSIVE ANGLO-NORMAN CATHEDRAL

A more decorative but extremely monumental version of
Romanesque architecture sometimes called Norman, or Anglo-
Norman, is found at Durham in England. Durham was a pilgrimage
centre for visitors to the tomb of St Cuthbert, and Benedictine
monks were established there around 1070. A Norman, named
Walcher, was appointed bishop in 1071, and he and his successor
planned the building of a great cathedral which was completed in
1133. The structure incorporates a new feature: the ribbed vault.
This is similar to a groin vault but has individual arches called ribs,
applied to the surface of the vault. Durham was the first cathedral
in England to be completely roofed in stone, and ribbed vaulting

25

became important in the new Gothic style, described in chapter 2.

Perhaps the most impressive feature at Durham is the decoration of the massive cylindrical piers of the nave. The piers are covered with incised and coloured patterns in spiral, chevron or diamond shapes. These piers alternate in the nave with even more massive compound piers, so that the design of the interior of Durham has a more rhythmic quality than the French churches described previously. Many of the archivolts of all three storeys of the nave are decorated with a sawtooth design, also different from the Continental examples of the Romanesque.

PISA CATHEDRAL COMPLEX: TUSCAN ARCADING

In Italy, the Romanesque style often took a more delicate turn. Geographically closer to examples of Greek and Roman architecture than their other European colleagues, Italian builders of the Romanesque period almost instinctively used pediments and columns, round arches, and patterned surface decoration covering more modest building materials.

One of the most attractive examples of Italian Romanesque is the cathedral complex at Pisa, in Tuscany. Throughout the Middle Ages, the Italian custom was to construct church, bell tower and baptistery as separate buildings. The most famous structure here at Pisa is, of course, the Leaning Tower – the bell tower – begun in 1174. For centuries subsidence in the ground beneath the tower has caused it to lean. The graceful tiers of slender arcaded marble columns rise, stage upon stage, like a large and fanciful wedding cake about to slide off its presentation platter. Fortunately, modern engineering has succeeded in stabilizing the tower. The cathedral itself, begun in 1063, is a cruciform basilica topped by a dome over the crossing. The façade of the cathedral follows the interior volumes of the basilica – tall in the middle, lower at the sides. There are hints of the shape of a pediment, the triangular gable that characterized the façade of a Greek temple. The entire exterior of the cathedral is decorated by rows and rows of arcades on colonnettes and by diamond-shaped panels of multicoloured marble which contrast with the clear whiteness of the building.

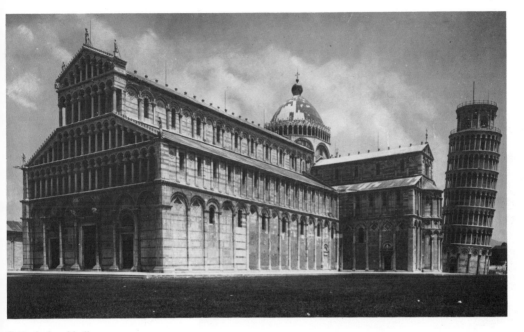

Cathedral and bell tower,
Pisa, 1063–1272.

HOUSES AND CASTLES

All the buildings described so far have been either churches or
abbeys. This is because few secular buildings of the Romanesque
period have survived. The lower the social level of the owners, the
less likely buildings are to remain standing today. We can, however,
get an idea of the dwellings of the medieval peasants of at least one
region by looking at some stone house-barns on the mountain of
Cebrero in Galicia, in northwestern Spain. The design of these
pallozas goes back to Celtic times. Each hut is approximately
rectangular but has wind-deflecting rounded 'corners'; the stone
structure is laid without mortar and topped with a thatched roof
that rises to a point. Built close to the ground for warmth – for
Cebrero is cold and wet, as well as windy – each *palloza* was divided
in two by a wooden partition. The peasants lived in the upland side
and their livestock in the lower part, so that drainage of the animals'
half of the hut did not inconvenience the human occupants. The
severity of Cebrero's climate also required the builders to leave
only tiny windows to let in light and air. In spite of the simplicity of
the *pallozas*, the appropriateness of their construction to site and
climate and the simple elegance of their radially thatched roofs
make them extremely impressive structures.

A few surviving Romanesque houses in urban centres suggest

27

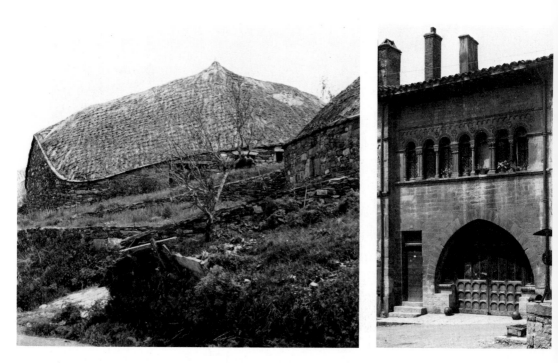

above
Palloza, Cebrero,
Galicia, northwest
Spain.

above right
Romanesque house, rue
de la République, Cluny,
before 1150.

how townspeople lived in the twelfth century. In a house built in
Cluny before 1150, the large pointed arch on the ground floor
opened into a shop. The shutters for this opening were made in such
a way that the shopkeeper could fold them back into the interior of
the shop to form trestle-supported tables for displaying merchan-
dise. Above the shop, a handsome gallery of seven small round-
headed windows, flanked by colonnettes and pilasters (flat panels
that imitate columns) with sculptured capitals, lights a single large
room where the shopkeeper's family lived. The fine quality of the
decorative carving of the gallery suggests that its sculptors were men
who had previously worked at the great monastery of Cluny nearby.

In other parts of England, France and Spain masons must also
have worked on secular buildings such as castles. In 1078, William I
decided to turn a timber castle in the angle of the Thames and the
old Roman London wall into a stone fortress. He wanted a strong
building which would impress the conquered Londoners and be a
place of refuge in case they rose up against him. The new monk-
bishop of Rochester, Gundulf, supervised the work. He arranged a
hall, great chamber, chapel, keep and store rooms all in one massive
rectangular tower with immensely thick walls and narrow windows.
Gundulf's chapel of St John in the Tower of London is his greatest
achievement and remains a fine example of early Norman architec-
ture in England.

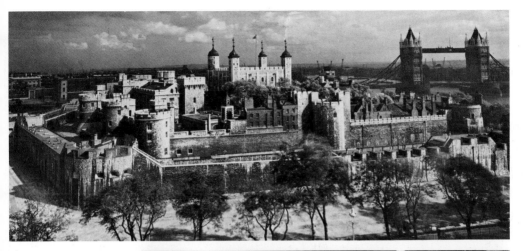

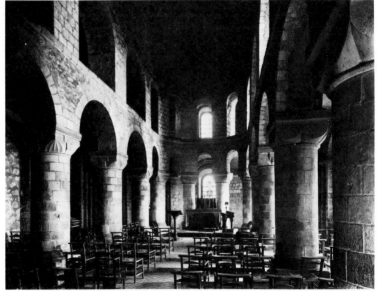

above
The Tower of London,
1078–87 with later
additions.

right
St John's chapel, Tower
of London, late 11th
century.

During the same period, Christians of the Iberian peninsula, eager to resist Muslim invasions, also frequently combined religious establishments with defensive structures. The most important Spanish fortress of this era is the well-preserved castle-abbey of Loarre in Aragon, near the Pyrenees. The site of the castle, on a high promontory overlooking a vast area, was apparently selected for ease of defence. As early as 1071, according to a papal confirmation, Sancho Ramírez, King of Aragon and Navarre (1045?–94) founded a monastery at Loarre in conjunction with an existing castle. An epitaph of 1095 carved on the portal of the castle chapel suggests that

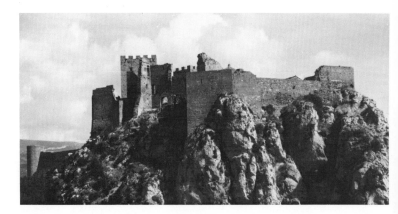

Castle-abbey of Loarre,
Aragon, 11th–13th
centuries.

this part of the structure was completed around the end of the eleventh century. Other castle structures include two large rectangular towers and miscellaneous domestic buildings. A thick wall punctuated by defence towers surrounds the whole. As in the gallery of the house in Cluny, much of the decoration of the architecture at Loarre looks very similar to work found in Romanesque churches of the same period.

SUMMARY OF ROMANESQUE ARCHITECTURE AND ART

We have seen how Romanesque architecture, with its heavy masonry, round arches, vaulted covering and logical marking-off of the subdivisions of structure, was varied by means of changes in proportions and surface treatment. The rebirth of monumental sculpture made possible the decoration of the portals of churches. The large smooth surfaces of the architecture also lent themselves to interior decoration in fresco. Popular themes included the Ascension of Christ, the Last Judgement, and the Apocalyptic Vision. Though there was too much variety in the work of artists at this time for us to be able to refer to a single unified Romanesque style, we do find some of the following characteristics in much of the art of the late eleventh and early twelfth centuries: a tendency to subdivide figures and compositions, rather than to emphasize the relationships of part to part; emphasis on symmetry and on line; a disregard for normal proportions of bodies; an emphasis on decoration and pattern for their own sake; and a tendency to make large compositions deliberately two-dimensional, thereby emphasizing spiritual over corporeal aspects.

2 Early Gothic architecture and art

During the twelfth century, a new style of building developed alongside the Romanesque. First developed in the Ile-de-France, the region around Paris, the new style was termed 'in the French manner'. Only later, when sixteenth-century Renaissance writers on architecture looked back disdainfully at the work of their predecessors, was the style called Gothic, the name by which we know it now. The implication was that this style, with its pointed arches, ribbed vaults and elaborate decoration, looked so unattractive and barbaric that it must have been designed by the Goths, the people who destroyed much of the civilization of ancient Rome. In spite of the original reference, the name has stuck, and is no longer derogatory.

THE ABBEY OF ST-DENIS, ABBOT SUGER, AND THE 'TRUE LIGHT'

The new architectural style first appeared in the 1140s at the royal abbey church of St-Denis, just north of Paris. The brainchild of a remarkable monk named Suger (1081–1151), the church was built as a replacement for an earlier one that had become too small for the crowds that flocked to St-Denis on feast days. Abbot Suger wrote of the need for a new church in a book on his administration of the abbey: 'the narrowness of the place forced the women to run toward the altar upon the heads of the men as upon a pavement with much anguish and noisy confusion'.

Suger began his reconstruction by creating a new narthex, or vestibule, and a monumental façade, dedicated in 1140. The church has now lost a number of its original elements; the illustration here is a nineteenth-century view that preserves more of the appearance of St-Denis in the twelfth century. Unlike the single-portal Romanesque façades seen in the last chapter, the façade of St-Denis

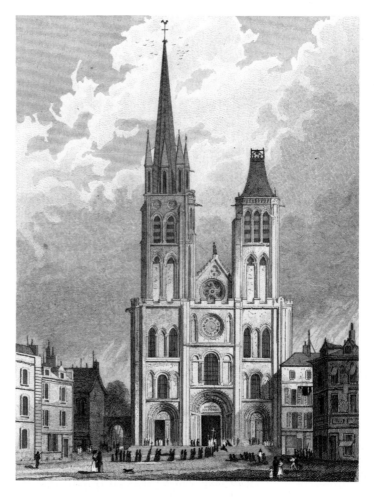

St-Denis, Paris.
West façade (1137–40) in
an engraving by Pugin of
1829, and plan.

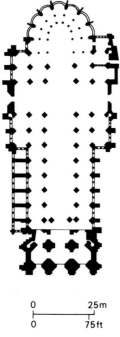

| 0 | 25m |
| 0 | 75ft |

has three portals, corresponding to the major longitudinal divisions of the church, the aisles and the nave. Heavy buttresses mark the façade into three clearly defined sections. The lateral ones, above the side portals, are continued upward into twin towers. Directly above the central portal is a large window that provides light for the narthex. Above this window appears another, a round one of a new type called a rose window.

Originally the portals of the west façade were decorated with an elaborate programme of sculptures organized by Abbot Suger around the theme of the Last Judgement, but so many of these have been damaged or destroyed that we cannot easily study this aspect of the church today.

Inside, however, we can still see clearly part of the chevet of St-Denis, built about 1140, much as Suger and his architect intended it

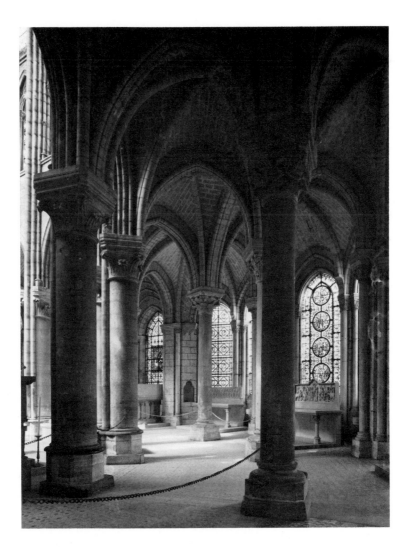

The ambulatory,
St-Denis, 1140–4.

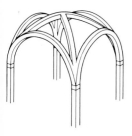

Ribs for a ribbed vault.

to look. The plan and the interior view show an ambulatory with seven radiating chapels. (The present choir and nave of the abbey church were rebuilt during the thirteenth century and are not part of Suger's design.)

The most important feature of the new style is ribbed vaulting. As we have seen in chapter 1, this differs from the groin vaulting commonly used in Romanesque architecture in having visible arches, called ribs, that are constructed separately from the webbing or principal surface of the vault. The ribs were usually constructed first, using a movable wooden framework called centering. Then the masons inserted thinner stones to form the webbing.

This new type of vault had several advantages over the older groin

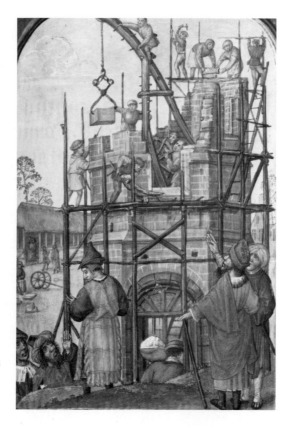

Centering still in position under a completed arch, Flemish manuscript painting, 15th century.

Vaulting with pointed arches made it easier to span different widths with arches of the same height.

vault. Some were structural. The ribbed vault was physically lighter than a groin vault of comparable area, and thus exerted less thrust or stress on the lower parts of the building that had to support the vaults. Also, ribbed vaults could be built on more complex plans than groin vaults. In the ambulatory and chapels of St-Denis, for example, the builders used trapezoids and pentagons. Other advantages of the ribbed vault were visual. The most obvious was the people simply liked the elegant look of the moulded stone ribs, which covered the seams where areas of webbing intersected. Another, more subtle advantage of this technique was that the ribs served as a diagram in stone of the structural forces of the building.

Another form, the pointed arch, was also used consistently in the new church at St-Denis. Like the ribbed vault, the pointed arch had been used in earlier structures and had certain advantages over the round arch preferred in most Romanesque buildings. The principal structural gain was the relative ease with which masons could build vaults over rectangular plans. Such bays had previously required arches of two different radii, which then rose to two different

34

heights, creating awkward transitions for the masons. Pointed arches, which are constructed on two centres, permit graceful and simple solutions to what had been difficult engineering problems. Another advantage of the pointed arch is that, because it reaches upward, it allows both the reality and the illusion of greater height than the round arch.

Yet another crucial element of the new Gothic style used in the chevet of St-Denis is the design concept sometimes described as 'point support'. This means the placing of a structure's piers or other supports at well-spaced intervals. The building then no longer needs to rely on solid walls for support, as in Romanesque architecture. Here in the chevet of St-Denis, the columns separating one space from another are so slender that the structure appears to be a double ambulatory, rather than an ambulatory with radiating chapels. As we look at the plan, we see that 'point support' was also used in building the exterior walls. Instead of the solid walls and narrow windows typical of a Romanesque chevet – for example, that of St-Sernin in Toulouse (page 6) – the outside of the chevet at St-Denis is composed of a series of short, radiating spur walls with large windows set into the intervals between them.

It is no accident that Abbot Suger's church was one of the first to make use of this combination of minimal walls and maximum areas of bright glass. For one of Suger's most cherished beliefs was that the contemplation of earthly brilliance, in the form of precious metals, jewelled objects, enamelwork and coloured glass, was an important means of leading the Christian believer to divine enlightenment. This idea, sometimes called 'anagogical movement', was expressed in part of an inscription that Suger had placed on the gilded bronze doors that were formerly in the central portal of the west façade:

> The dull mind rises to truth through that which is material
> And, in seeing this light, is resurrected from its former
> submersion.

Fortunately for Suger, and also for the subsequent development of Gothic art and architecture, his desire to put this belief into practice coincided with the availability of craftsmen skilled in the making of bright objects, especially stained glass.

Abbot Suger, detail of
stained glass window
from St-Denis, mid 12th
century, reset in a
14th-century window.

STAINED GLASS

Stained glass is made by adding various chemicals, such as
manganese or cobalt, to molten glass while it is still in the glass-
furnace. The glass remains translucent but takes on different
colours, depending on the substances added to it. The portrait of
Abbot Suger himself, part of a window at St-Denis, clearly shows
the translucence of the medium. Traditionally, sheets of glass were
made by one of two methods. One method produced 'crown' glass.

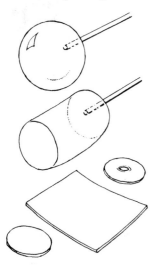

Making 'muff' glass.

The glassblower took up a blob of molten glass on the end of his
blowpipe, and spun the pipe rapidly. Centrifugal force caused the
glass to form a flat, plate-like shape, slightly thicker at its centre than
at the rim. The other common method resulted in 'muff' glass. The
glassmaker blew a long balloon of glass, snipped it off the blowpipe
and also cut off the opposite end of the balloon. The balloon became
a cylinder or 'muff' that could be slit down the middle while still
warm, opened up and flattened out to form a sheet. Individual
pieces were then cut out of the cooled glass with a diamond point or
other glass-cutting tool, and laid out on a work table according to a
predetermined design. The glassmaker painted such details as facial
features on to the coloured glass with black paint. He fitted the
individual pieces together by surrounding each with a flanged strip
of flexible lead and then soldering the leads together. He integrated
the lead strips into the design by using them as black outlines around

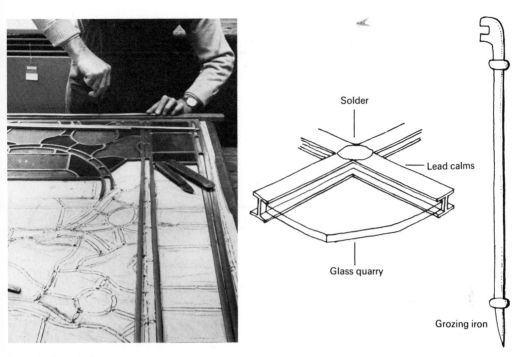

Solder

Lead calms

Glass quarry

Grozing iron

Stained-glass window construction. The grozing iron was used to cut the glass.

figures and objects. Small panels were grouped into large compositions. When it was time for installation in the window frames prepared for the stained glass by the masons who had built the church, workmen hung the individual panels by hooks from iron frames called armatures. These were necessary stabilizers, because the combination of glass and lead is very heavy and liable to damage in a high wind.

A single window frequently contained many subjects. These could be episodes from a single story, or themes connected symbolically. Unfortunately, most of the glass of St-Denis has now been replaced or repaired by restorers, but Suger left us enough descriptions to make it clear that the windows were meant to carry elaborate iconographical messages to the faithful. The contemplation of the brilliantly coloured images guided them to a knowledge of the truths depicted. Suger could not have found a more appropriate medium than stained glass – a medium dependent on light for its jewelled effects – to convey the idea that the contemplation of material beauty leads to an understanding of the divine. In the chevet of St-Denis, then, the new style of building with its elegant ribbed vaults, pointed arches and skeletal constructions was enhanced by a flowering of the technique of stained glass.

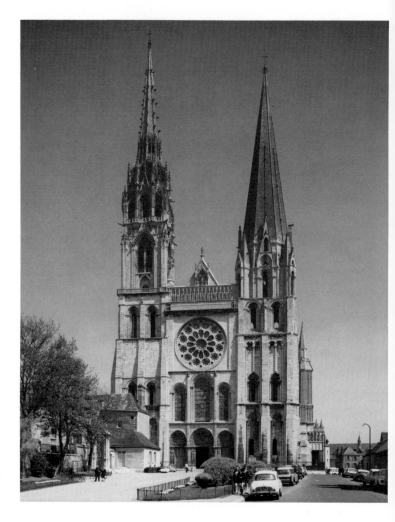

West façade, cathedral of
Notre-Dame, Chartres.

CHARTRES: THE ROYAL PORTAL AND THE STATUE-COLUMN

About 90 kilometres (56 miles) southwest of Paris stands the
cathedral of Notre-Dame of Chartres, on the site of the earliest
church dedicated to the Virgin Mary in France (*Notre-Dame* means
'Our Lady' in French). The original cathedral was founded in the
fourth century; in the ninth century, Charles the Bald, grandson of
Charlemagne, presented to Chartres Cathedral its principal holy
relic, the 'tunic of the Virgin', a piece of cloth thought to have been
worn by the Virgin Mary at the birth of Christ and which was
famous for working miracles. Chartres became and remains an
important goal of pilgrimage.

The present cathedral was built between the twelfth and

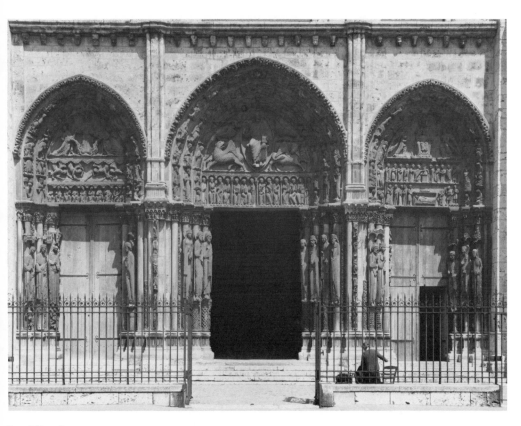

Royal Portal, *c.* 1145–55,
west façade, Chartres
Cathedral.

sixteenth centuries. One of its earliest surviving portions is also one
of the most interesting. This is the Royal Portal of the west façade,
made about 1145–55.

The Royal Portal is in fact three portals opening into the width of
the nave of the cathedral. They are survivors from an earlier
cathedral, which was much smaller than the present one. The scale
of the portals is thus smaller than in the façade of St-Denis, where
each portal corresponds to one of the three principal spaces of the
church. The portals are similar in structure to those of Moissac or
Conques or Toulouse in having a sculptured tympanum above each
of the doorways. But new elements are now included. Framing each
tympanum are sculptured archivolts, decorative arches whose
curves follow those of the tympanum. The archivolts are composed
of individual voussoirs, on each of which is sculptured a figure. This
inseparability of structure and decoration is characteristic of the
Gothic period.

Below the level of the archivolts, each doorway is flanked by
slender columns with elongated human figures attached to them.

39

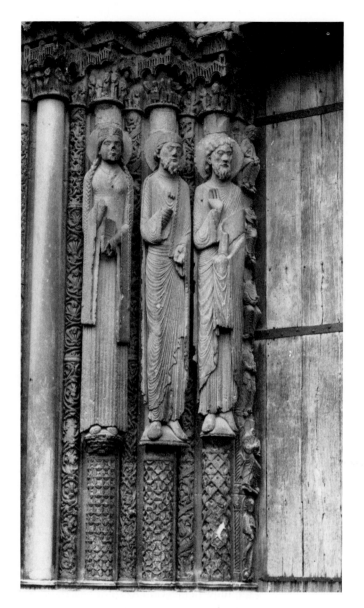

Statue-columns of kings and queens of the Old Testament, lefthand jamb, central portal, Royal Portal, Chartres Cathedral.

These are statue-columns, a new invention, found only during the Gothic period. Unlike the caryatid figures of Greek architecture – standing female figures substituted for columns – statue-columns are sculptures applied to colonnettes. These slender kings and queens of the Old Testament conform so closely to the cylindrical colonnettes supporting them that the figures, with their tightly pleated draperies, seem almost to have been unrolled on to the architecture.

The three tympana depict different stages of Christ's life. At the right is his infancy, at the left his ascension into heaven after his resurrection, and in the middle, Christ sits enthroned in heaven. The archivolts surrounding the three tympana elaborate upon the central themes.

At the top of the righthand tympanum is the Virgin in Majesty with the Christ Child on her lap. Here Mary symbolizes the Throne of Wisdom, chosen for Christ by God the Father. Below, in the two lower rows of the tympanum are scenes of the infancy of Christ: the Annunciation, the scene in which the Angel Gabriel informs the Virgin that she is to bear God's son; the Visitation, in which the Virgin visits her cousin Elizabeth, the mother-to-be of St John the Baptist; the Nativity; the Adoration of the Shepherds; and the Presentation of Jesus in the Temple. The prominence given to the Virgin Mary in this tympanum is quite understandable when we remember that the cathedral of Chartres is dedicated to her.

Mary's significance as the throne of heavenly wisdom (we sometimes speak of a 'seat of learning') is paralleled in the archivolts, which refer to earthly education. At the time the Royal Portal was being planned, Chartres was the home of a thriving cathedral school. The branches of learning of the medieval curriculum were called the seven Liberal Arts. In the archivolts are depictions of practitioners from ancient times of each of the Liberal Arts. And with these are female figures personifying the arts themselves: Arithmetic, Geometry, Music, Astronomy, Grammar, Dialectic and Rhetoric. The appeal of the figure of Grammar rebuking one of her pupils by pulling his ear is as vivid today as when it was carved.

The lefthand tympanum shows the Ascension of Christ, with angels bending down out of the clouds to tell the apostles that Christ will return once more to earth. Again the voussoirs expand upon the central theme. They represent the twelve signs of the zodiac and the twelve traditional Labours of the Months. These images represent a permanent cycle of the seasons on earth and in the heavens, symbols of the physical universe that Christ is leaving.

In the central tympanum sits a magnificently serene Christ in Majesty, surrounded by symbols of the four evangelists. Here the voussoir-figures are even more closely allied to the tympanum than in the lateral tympana, for the angels and twenty-four elders

Grammar teaching, righthand portal, archivolt, Royal Portal, Chartres Cathedral.

depicted in the voussoirs are part of the Apocalyptic Vision of St John, as we have seen in chapter 1.

Although the style of many of the individual sculptures of the Royal Portal remains close to the Romanesque, there are new elements that will appear increasingly in Gothic monuments. One is the statue-column placed on the jamb of a portal. Another is the decoration of both tympanum and surrounding archivolts in the same portal. But perhaps the most important new tendency is the deliberate association of the sculptures of adjacent portals into complex but lucid iconographical programmes.

LAON CATHEDRAL AND THE CONQUEST OF HEIGHT

To see what becomes of the new Gothic style after its first appearance in the ambulatory of St-Denis, we can turn to the cathedral of Notre-Dame at Laon (the *a* is silent), 135 kilometres (84 miles) northeast of Paris. The building was begun about 1155, though construction continued throughout the second half of the twelfth century. The interior of the nave and transept of Laon is typical of an experimental phase of early French Gothic architecture. The builders were trying to build ever higher and lighter cathedrals. At Laon there are four rather than the usual three storeys in the wall elevation (the sequence of storeys). These are the main arcade, gallery, triforium (an arcaded passageway in the thickness of the wall), and clerestory. The distance from floor to top of the nave vaults is 22 metres (about 70 ft). The builders achieved more light by placing windows not only along the side aisles and in the clerestory, but also now in the galleries. Only the triforium is without windows.

Another trend of early French Gothic architecture seen clearly at Laon is the 'diagramming' of the structural forces of the building. This was done by making the vertical supports, as well as the ribs they carry, project strongly from the planes of the walls and vaults to which they are attached. Thus, we can see what looks like a skeleton of stone defining the interior space of the church. The designer of Laon was even over-eager for us to understand the structural relationships within the building; he bundled the colonnettes together on the walls above the main arcade for decoration, although

opposite
Nave, cathedral of
Notre-Dame, Laon,
begun *c.* 1155.

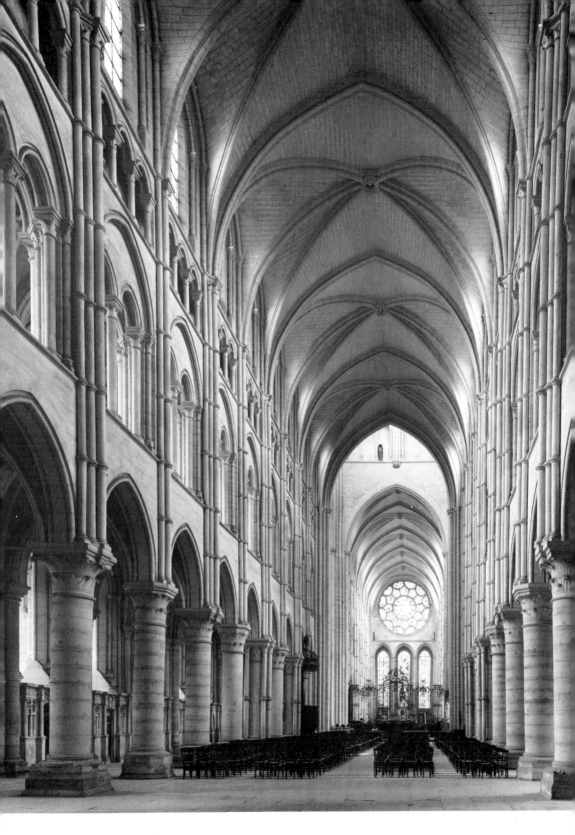

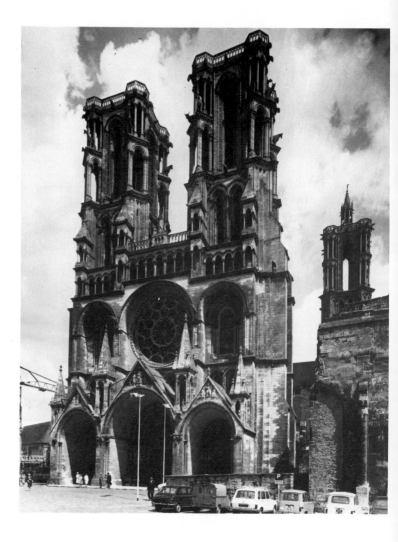

West façade, Laon
Cathedral, *c.* 1200.

they do not really support the ribs of the vaults above. The overall
impression made by the interior of the cathedral is of height, of
lightness, of clear lines, but also of a multiplicity of small units.

The façade of Laon was constructed later, around 1200. Though
thick and massive, it too was made up of many small elements. The
ground storey of the façade consists of three portals, each preceded
by a barrel-vaulted porch and surmounted by a gable. Between the
gables of the central and lateral porches are little arcaded structures
capped by tall polygonal spires. As at St-Denis, each portal
corresponds to one of the principal longitudinal volumes of the
interior of the church. Above the portals, the façade continues its
three-part division. Two slightly pointed individual windows of a
type called lancet are placed above the side portals. Above the

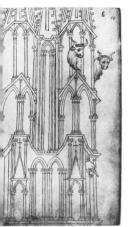

North Tower of Laon
Cathedral, from *The
Sketchbook of Villard de
Honnecourt.*

central portal is a rose window, more delicate than the one seen on the west façade of Chartres. This rose is filled with tracery, ornamental stonework dividing the circle into an openwork pattern. Above the two lower storeys of the façade is an arcaded gallery in three sections, the one in the middle set slightly higher than the others.

Crowning each side of the façade are flat-topped twin towers which house a curious herd of stone oxen which perch on the roofs of little arcaded structures at each of the corners of the towers. Medieval travellers found the oxen as curious as we do today. An architect named Villard de Honnecourt, who kept a sketchbook recording what he saw during his travels around Europe in the early thirteenth century, drew the north tower of Laon with its oxen. To this day, no one knows why the oxen were placed there.

NOTRE-DAME DE PARIS AND THE FLYING BUTTRESS

Like the cathedrals of Chartres and Laon, and most of the cathedrals of the Gothic period, the cathedral of Paris was dedicated to the Virgin Mary. But such is the importance of this city that both the English-speaking and French-speaking world refer to its cathedral as simply 'Notre-Dame'.

Notre-Dame is especially remarkable for its great size and the elegant regularity of its design, and for the introduction of a new technical device, the flying buttress. The construction of Notre-Dame began in the 1160s. It is one of the largest of Gothic cathedrals – the building is 150.20 metres (493 ft) long and its main vaults 32.50 metres (nearly 107 ft) high. By about 1175, when preparations were being made to support the vaults of the nave, flying buttresses were introduced. A flying buttress is an arch or half-arch that transmits the thrust of a vault from the upper part of a wall to an outer support or buttress. Usually, flying buttresses were set out in pairs, one on each side of the main vault bay being supported. In chapter 1 we saw the same task of containing thrust being performed by the half-barrel vaults above the galleries of Pilgrimage Road churches. The disadvantage of the Romanesque arrangement was that it did not permit windows in the upper parts of buildings, which

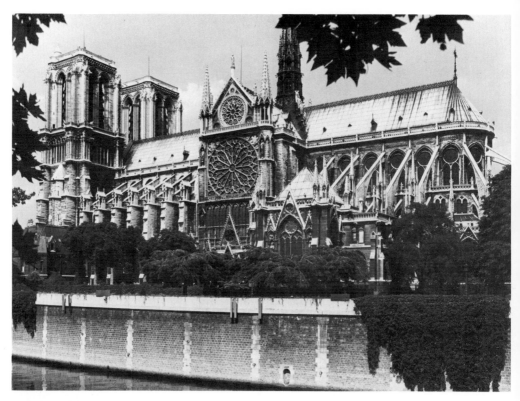

Cathedral of Notre-
Dame, Paris, begun
1163.
South flank and (*below*)
transverse section of
flying buttresses.

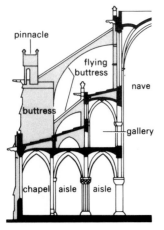

pinnacle

flying
buttress

nave

buttress

gallery

chapel aisle aisle

remained dark and gloomy. But the flying buttress, the Gothic
solution to the problem of containing thrust, concentrated mass at
relatively few points. The flying buttresses were carried on the
outside of the building, above the aisle roofs, almost as though the
roof had been lifted off the gallery of a Romanesque building,
exposing the half-arches beneath. The external mass of the building
became more skeletal, just as the internal supports had been pared
down. The Gothic building became a stone cage, with stained glass
filling what had formerly been solid wall.

The interior of Notre-Dame is restrained and harmonious. The
interior elevation (now three storeys but originally four) looks much
flatter than that at Laon. Wall shafts are more slender, mouldings
project less, and the clerestory windows are set close to the inner face
of the wall, rather than near the outer face, as at Laon. The vertical
and horizontal divisions of the west façade, planned near the end
of the twelfth century, are much more like a grid than at Laon, and
the three portals are much shallower. This precise, sophisticated
treatment befits the lofty status of Notre-Dame as the principal
cathedral of France.

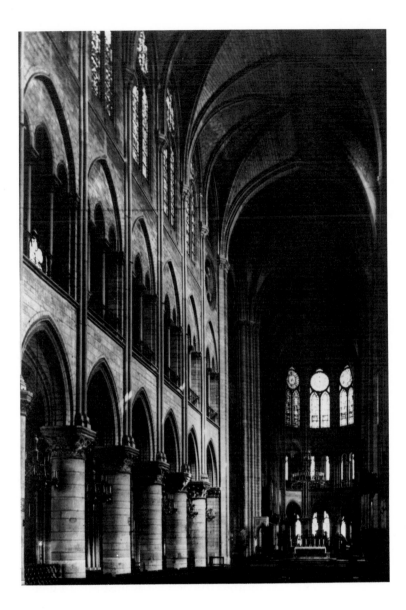

Nave looking east,
Notre-Dame, Paris.

CANTERBURY CATHEDRAL: THE EARLY ENGLISH STYLE

Gothic architecture in England between 1170 and 1240 is sometimes called Early English. It is characterized by simple lancet window openings without tracery, much like the windows and doorways that we have just seen in French Gothic buildings of the twelfth century.

One of the first appearances of the Early English style is in the choir of Canterbury Cathedral, designed by two master masons, as

medieval architects were generally termed. After a calamitous fire in 1174 destroyed an earlier building, the first of these master masons, a Frenchman called William of Sens, began a new choir. His supervision of the work was cut short by an accident that was vividly recounted by a local chronicler, the monk Gervase of Canterbury:

> And having, in the next place, completed on both sides the triforia and the upper windows [that is, the clerestory], he was, at the beginning of the fifth year, in the act of preparing with machines for the turning of the great vault, when suddenly the beams broke under his feet, and he fell to the ground, stones and timbers accompanying his fall, from the height of the capitals of the upper vault, that is to say, of fifty feet [15 metres]. Thus sorely bruised by the blows from the beams and stones, he was rendered helpless alike to himself and for the work, but no other than himself was in the least injured. Against the master only was this vengeance of God or spite of the devil directed.
>
> The master, thus hurt, remained in his bed for some time under medical care in expectation of recovering, but was deceived in this hope, for his health amended not . . .
>
> And the master, perceiving that he derived no benefit from the physicians, gave up the work, and crossing the sea returned to his home in France.

Work continued under William the Englishman. The two master masons had decided against using a four-storey elevation to obtain great height, and planned instead a choir with only three storeys. Throughout the design, horizontal elements are more prominent than vertical ones. This greater emphasis on horizontality is characteristic of much English medieval church design of all periods. Other differences from the twelfth-century French Gothic style are the use of multiple mouldings for decoration on arched and vertical forms, and the application of decorative shafts of black Purbeck marble for contrast against light limestone. The resulting design seems even more linear and ornamental than was popular in France.

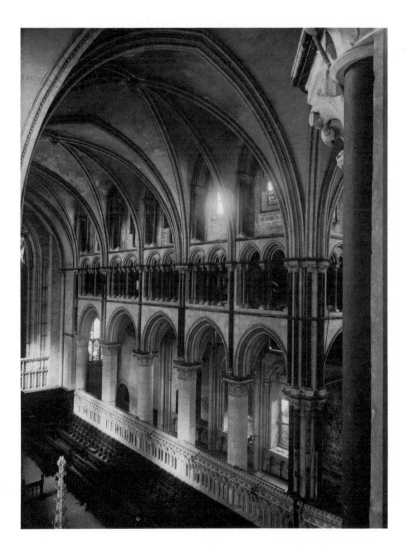

Choir, Canterbury
Cathedral, begun 1175.

EVERYDAY CRAFTS AND PRECIOUS TREASURES

Up to this point we have looked primarily at structures made for shelter, defence and worship. People often chose to decorate these buildings with stone sculptures, wall paintings, stained glass or wall hangings. But people also asked artists and craftsmen to make clothing, furniture, utensils, tools, ornaments and even books. Some of these objects were made by using ordinary materials and simple techniques. Spinners and weavers produced plain woollen cloth to be cut and sewn into clothes. Blacksmiths beat iron into horseshoes, hooks, chains, hand-tools, ploughshares and weapons. Carpenters shaped wood for the timbered interiors of buildings, furniture,

49

Three men shoeing a horse. Detail of archivolt, north portal, cathedral of St-Etienne, Cahors, mid-12th century.

farming tools and kitchen utensils, as well as boards for use in binding books. Leatherworkers made shoes, belts, straps, animal harnesses, water bottles, elegant covers for books, and cases for valuables.

But for rich people and for the Church, craftsmen made precious goods of valuable materials and intricate workmanship. Again, as we saw in the case of architecture, things made for the rich and powerful are more likely to survive than things made for the poor. Expensive materials such as ivory, gold and silk last longer and are usually handled carefully. Thus, the treasures that have come down to us from the Middle Ages – ivory carvings, gold and silver objects decorated with enamel, silk textiles, manuscripts – are mostly things made for the Church or for private persons of important rank.

NICHOLAS OF VERDUN, THE KLOSTERNEUBURG ALTAR AND TYPOLOGICAL PARALLELS

One such precious object is an altar made for the Austrian monastery of Klosterneuburg on the Danube. An inscription on the altar names the patron, Provost Wernher, head of the monastery (1168–94); the date of completion, 1181; and the artist, Nicholas of Verdun. The artist's name suggests that he came from the valley of the Meuse River just west of the Rhine, a region long famous for its metalwork. The altar consists of 51 enamel plaques arranged as a triptych – a central panel flanked by lateral wings. (Originally, there were only 45 plaques, arranged to form a pulpit. After a fire in 1330, Provost Stephen of Sierndorf (1317–35) had the panels converted into an altar, and commissioned six new plaques to complete it.)

Nicholas worked in the medium called champlevé enamel.

Enamel is a glassy substance applied to a metal or other backing; the object is then fired in a kiln to fuse the two substances. The champlevé technique was the most popular in western Europe in the twelfth century. The name means 'raised field' in French, and refers to the practice of cutting a design into a metal plate in such a way as to leave thin raised lines that create compartments to hold the enamel. Although enamel may be made in almost any colour, Nicholas chose to use red and several shades of blue against gold plates. He built up broad areas of enamel for backgrounds and carefully tinted the incised lines within figures. These lines, called contour lines, help the figures to appear three-dimensional.

The individual plaques are rectangles topped by trefoils. They are rather large for enamelwork, measuring 20.5 × 16.5 cm (8¼ × 6½ in), presumably because they were made for a pulpit, and would need to be seen from a distance. The plaques are now arranged in three rows to read as seventeen columns of three plaques each. Latin inscriptions arranged around each plaque identify each scene. The top row represents Old Testament scenes from the period 'before the Law' – that is, before Moses received the Ten Commandments. The bottom row contains Old Testament scenes from the period 'under the Law' – after God gave the Ten Commandments to the Israelites. And the middle row depicts scenes from the era 'under Grace' – that is, since the time of Christ.

The Old Testament scenes prefigure the New Testament subjects of the middle row of plaques. Such arrangements of Old and New Testament subject matter are often called typological parallels, or simply typology. The Old Testament scenes represent a 'type' or antecedent of the New Testament event. These juxtapositions had been known from the earliest periods of Christianity, but became especially popular in the theology and art of the twelfth century. The theological complexity of the programme of the Klosterneuburg Altar suggests that Nicholas of Verdun had help in planning the arrangement of scenes, perhaps from Provost Wernher himself.

The illustrations show a group of three such scenes from the Klosterneuburg Altar: Joseph in the Well, the Entombment of Christ, and Jonah in the Belly of the Whale. There are parallels among the three stories. All three compositions show three people

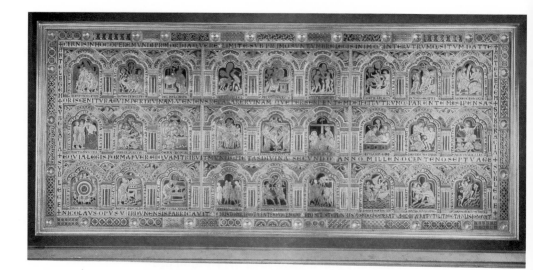

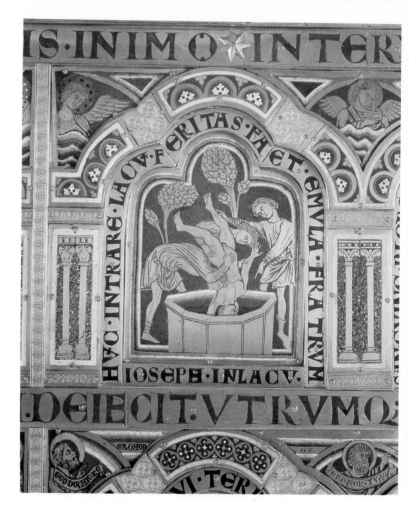

Nicholas of Verdun,
Klosterneuburg Altar,
completed 1181,
Stiftsmuseum,
Klosterneuberg.
Central panel (*left*) and
three plaques showing
Joseph in the Well, The
Entombment of Christ,
and Jonah in the Belly of
the Whale.

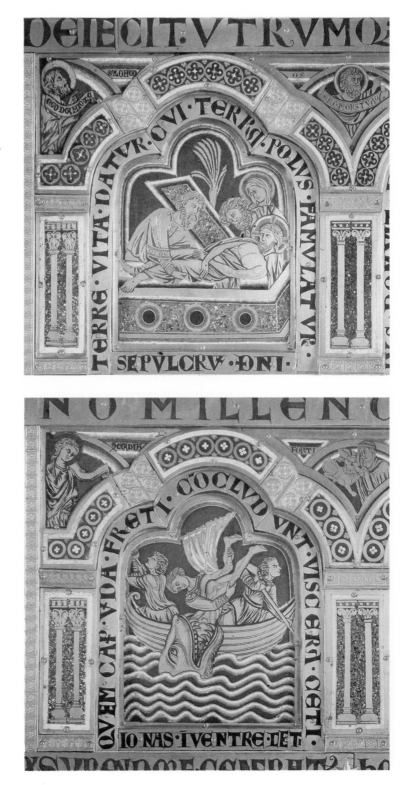

throwing or depositing a fourth into a receptacle: a well, a sarcophagus (coffin), or the mouth of a whale. In all three stories, the captive later escapes his confinement. Joseph's brothers lift him out of the well and sell him to passing merchants, the whale vomits Jonah on to dry land, and Christ is resurrected after his death. The similarities among the three events depicted are emphasized by showing the principal figures nude, and placing them as close as possible to the centres of the compositions.

Nicholas of Verdun created a remarkable new style in which we can trace perhaps three influences: the art of Greece and Rome that had survived in earlier styles of medieval art, the contemporary art of the Byzantine Empire, and direct observation of nature, especially of the human body. Characteristic of this style, which is sometimes called Transitional (that is, between Romanesque and Gothic), are the fluttering, parallel, trough-like folds of cloth and the remarkable command of human anatomy. Nicholas's figures feature especially precise movements and lively expressions.

THE INGEBORG PSALTER

The Ingeborg Psalter is an illuminated manuscript made about 1195 in northeastern France. Ingeborg was a Danish princess who became the wife of King Philip Augustus of France in 1193. A psalter is a collection of the Psalms of the Bible; this one contains a group of full-page pictures preceding the text.

It may be difficult for us, who can obtain books very easily, to comprehend the high regard that people of the Middle Ages felt for books like the Ingeborg Psalter. First of all, books were very costly. With neither paper nor movable type nor photographic reproduction available, all phases of book production were hand-done. The normal writing surface for books was vellum, the specially tanned, split and polished hide of sheep or calves. This was an expensive material, especially if the vellum was obtained from sheep, who might otherwise have produced valuable wool each year. In a scriptorium (the workshop, usually in a monastery, where books were made) the monks bound and trimmed book-sized sheets of vellum. Pages were laid out with ruled lines. Men or women

skilled at writing, called scribes, copied texts on to the vellum in black ink. The scribes left spaces to be filled in with titles and chapter headings written in red ink. These were called 'rubrics' (a word we still use to mean a heading or title), from *rubrica*, Latin for the red earth pigment used to make the ink. Other artisans decorated the manuscripts with painted pictures and other ornament. The paint used was usually gouache, an opaque mixture of pigments and a binder such as gum arabic, producing something similar to modern poster paint. Since one of the most common pigments used in medieval manuscript painting was a red oxide of lead called minium, anyone who worked with minium was called a *miniator*, and the work he did was called a *miniature*. The small size of most manuscript images eventually led to the present use of the word 'miniature' to mean something tiny.

The Ingeborg Psalter is unusual among medieval manuscripts in that its pictures do not correspond to its text. Two events from the second chapter of Matthew in the New Testament make up one such picture. King Herod, in an effort to destroy the infant king about whom he had heard, commanded the killing of all children in Bethlehem under the age of two. Joseph, the Virgin Mary's husband, was warned of this in a dream and escaped with his family to Egypt. This is the lower scene, the Flight into Egypt. The fate of less fortunate families is shown on the upper half of the page, which depicts the Slaughter of the Innocents. The lower scene is merely lively; in an unusual gesture, Joseph hands the Christ Child to his mother. But the upper scene is brutal. Infants in their mothers' arms are stabbed to death. A mother falls down into the left foreground, kissing the severed head of her son. At the lower right, a mutilated little corpse has lost its head and arm. Above it all, Herod watches impassively from the safety of his throne.

It would have been difficult to depict such active scenes without the advances made by Nicholas of Verdun in the Klosterneuburg enamels. We notice several points of similarity with his work. One is the use of trough-fold draperies. Another is the understanding of human anatomy. Still another similarity is the combination of gold with strong colours, especially red and dark blue. It seems likely that the unknown artist who painted this page of the Ingeborg Psalter knew about the work of Nicholas of Verdun.

Si come nostre, sen ua en egipte.
vanme

Early Gothic architecture and art

SUMMARY OF EARLY GOTHIC ARCHITECTURE AND ART

While some artists and builders of the twelfth century continued to work in the Romanesque style, others experimented with a new style, now called the Gothic. First apparent in architecture, it is characterized by the use of ribbed vaults and pointed arches, increasingly skeletal construction, and tracery. We see a new feature called the flying buttress, which enables the builders to build to greater heights than previously possible. Sculptors experimented also, trying out a new form called the statue-column in many of the portals designed for the new Gothic buildings. The planners of iconographical programmes grew more inventive, sometimes relating groups of three sculptured portals to one another through their subject matter. Painters, metalsmiths and other artists who made small objects also used elaborate symbolism, such as typological parallels between Old and New Testament subjects. The same artists, especially those who worked in two-dimensional media like painting and enamelling, began to emphasize line, whether outline or contour line, in their work. This emphasis parallels the clear definition of structural elements in Early Gothic architecture, with its projecting wall shafts, ribs and horizontal mouldings.

left
Slaughter of the
Innocents and Flight
into Egypt, Ingeborg
Psalter, Musée Condé,
Chantilly, ms. 1695, fol.
18 v, made *c.* 1195.

3 High Gothic architecture and art

High Gothic is the name usually given to the style of art and architecture in thirteenth-century Europe. Its greatest glory is the French cathedral with its embellishments of stained glass and sculpture. During the same period, manuscript painters brought their art to a high degree of perfection.

THE STONEMASONS AND GOTHIC ARCHITECTURE

Masons' marks.

The near miracle of High Gothic architecture could not have been created without the remarkable knowledge and organization of professional masons. Medieval churches were built by stonecutters, carpenters, plumbers and other artisans, all under the direction of a master mason whose role, as we have seen in chapter 2, was something like an architect's today. More is known about the masons, the men who worked with stone, than about any of the other craftsmen, because the masons kept better records. Most of the masons travelled to towns and cities where buildings were being erected. In each locality, they organized themselves into lodges, associations housed in structures that served as workshops and administrative centres. The lodge looked after its members, sometimes providing them with shelter as well as work. The lodge also kept watch on the behaviour of its members.

One way to oversee the work was by assigning masons' marks, distinctive signs such as the ones illustrated. Each man had a mark of his own that he carved into each block of stone he cut. He was paid for cutting the stones that bore his mark. Most marks are made up of straight lines, which are easier to chisel than curves. Each mason kept his own mark throughout the time he worked at a given lodge; sometimes sons inherited marks from mason fathers.

The master mason supervised all building operations. Although drawn from the ranks of the ordinary masons, he was much more

Tracing floor, room over
north porch, Wells
Cathedral, begun
c. 1180.

than a stonecutter. He was both designer and contractor, and he had
to know about all phases of construction. He had to collaborate with
whoever was paying for the building to decide what was to be
constructed. He had to secure building materials, not an easy task in
an age dependent on waterways and oxcarts for most hauling, and to
call in each set of workmen as they were needed, and to show them
the design of the building.

Just how this last task was carried out is not completely clear to us,
for the medieval master mason did not possess much in the way of
drawing materials. Vellum was far too expensive for casual use. A
device found at some building sites was a tracing floor, a special
plaster or stone surface on the floor of the master mason's workshop.
On this surface the master mason or a close associate drew the
profiles of the various mouldings, the curves of vaults, and other
measurable, repeated elements of a building's design. From these
were prepared templates or moulds which the individual masons
could use in cutting the various stones needed for the building.

CHARTRES CATHEDRAL : A GOTHIC ENCYCLOPAEDIA

On the night of 10 June 1194, a fire devastated a large part of the city
of Chartres, including the bishop's palace and all of the cathedral
except the west façade. The chapter, the group of religious men
responsible for the cathedral, met to decide what to do. Their
decision to rebuild the cathedral was prompt, almost inevitable.
Such was the importance of Chartres as the centre of the cult of the

59

Virgin in France that the secular and religious communities alike perceived the fire almost as a mark of divine favour: an opportunity to build a splendid new church that would surpass anything in Europe.

At this time, the diocese of Chartres was possibly the largest and wealthiest in France. It was the focus of tremendous commercial activity in the form of great fairs, annual markets coinciding with the four feasts of the Virgin: Purification, Annunciation, Assumption and Nativity. These fairs were held in the streets and squares around the cathedral, and came under the authority and protection of the cathedral chapter. Business and religious interests therefore coincided and made it all the more worthwhile for the chapter to allocate a large part of the cathedral's revenues to an immediate reconstruction of the building. Craft and merchant guilds of the town gave generously as well; there is still in the chevet of Chartres a window donated by the butchers' guild. As we have seen elsewhere, the gift of an important relic could also spur contributions to a building fund. After the fabulous sale of relics seized as booty in 1204 by the crusaders who sacked Constantinople, Louis, Count of Chartres, purchased and sent to the cathedral the head of St Anne, mother of the Virgin. Other important donors whose names we know were Queen Blanche of Castile (1188–1252), mother of St Louis, King of France, who paid for the windows of the north transept façade; and Peter of Dreux, Duke of Brittany, who gave not only the corresponding windows on the south transept, but also the sculptures of its portals.

Unfortunately, no records tell us the names of the master masons who designed the new building. Judging from its design, which in significant ways resembles the cathedrals at Laon and Soissons, the first master mason may have been trained in the northeast of France.

The plan of the new cathedral resembles the plans of the Pilgrimage Road churches: a cruciform basilica with transepts, aisles and radiating chapels set about an ambulatory. Here, though, the chevet is bigger and more complex, and the choir is ringed by a double aisle and ambulatory, as in the chevet of Notre-Dame in Paris.

INTERIOR OF CHARTRES CATHEDRAL The interior design seems deceptively simple. The wall elevation has only three storeys: main

Cathedral of Notre-Dame, Chartres, begun *c.* 1194.

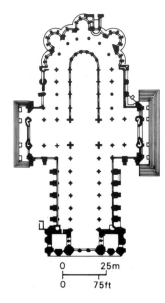

0 25m

0 75ft

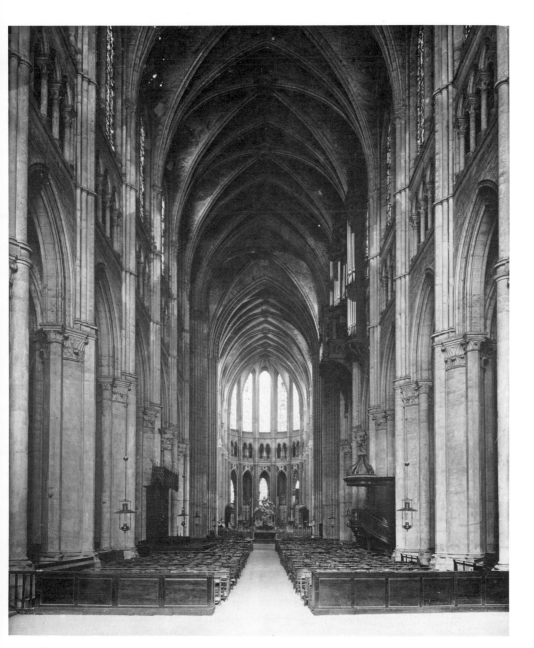

Nave, Chartres
Cathedral.

arcade, triforium, and clerestory. The unusually tall clerestory
begins below the level of the springing of the vaults, the point at
which they begin to curve. Thus, the clerestory and the main arcade
are of nearly the same height – large, light areas separated by the
windowless triforium. Within each clerestory bay, a large lobed
oculus, a circular window with a scalloped edge, surmounts a pair of

lancets. Lower down, the main arcade bays are lit by lancets in the outer walls of the aisle. Very little of the visible surface of the cathedral interior is what we normally think of as 'wall'. And what there is appears to be extremely thin.

As at Laon, the system of supports and supported elements is clearly diagrammed. Each pier of the main arcade consists of a massive core surrounded by four colonnettes. These are set around the core at regular intervals so as to give the piers 'corners'. Although the core and colonnettes of each pier have a common moulded base, called the socle, they are differentiated at the level of the capital. Here the colonnettes have small, individual capitals and the pier-cores have larger ones proportional to their greater diameters. As we look down the nave, we see an alteration of piers with an octagonal core combined with cylindrical colonnettes, and piers with a cylindrical core surrounded by octagonal colonnettes. Above the level of the main arcades, bundles of wall shafts continue up through the triforium level to the springing of the vaults. There the wall shafts branch out into the ribs of rectangular four-part vaults.

The wall elevation forms a regular grid. The three storeys are separated from one another by slightly projecting mouldings called string-courses. Between these, the dark ribbon of the triforium wraps around the interior of the building. But the vertical direction dominates the grid. Not only is Chartres Cathedral tall (the vaults are 36.5 metres (119 ft 8 in) above the floor) but it *looks* tall, primarily because of the strong projection of the piers and wall shafts. This emphasis on verticality, both delighting the eye and directing the mind toward heaven, became an important characteristic of the mature Gothic style.

STAINED GLASS OF CHARTRES CATHEDRAL The sense of harmony and mystery which overwhelms the visitor to Chartres is enhanced by the stained glass, perhaps the most superb in medieval Europe and still intact today. The colour harmonies are based on deep blues and brilliant reds. Together they cast a dappled purplish light over the greyish limestone of the cathedral's interior, softening the crispness of the stonework.

Mary is shown in the choir window *Notre-Dame de la Belle*

Verrière – 'Our Lady of the Beautiful Stained-glass Window'. As with the enthroned Madonna of the Royal Portal tympanum, she is shown as the Queen of Heaven, with both halo and crown. The infant Christ sits on his mother's lap. She is flanked by small pairs of kneeling angels who hold candlesticks and swing incense burners. Above her head flies a white dove, traditional symbol of the Holy Spirit.

The central panel with the Virgin and Christ survived the great fire of 1194. The other parts of the window are thirteenth-century additions. Yet the composition is orderly and clear. The monumental figures of Mary and Christ face us; the adoring angels are arranged symmetrically on either side. Frontality, symmetry, and the extremely large size of the most important figure in a composition – all of these features can be seen in Romanesque sculpture; but here, in the medium of stained glass, colour enhances the clarity of the design.

The north window of the three mid-twelfth-century lancets above the Royal Portal shows the Tree of Jesse. This window is modelled on a similar *Tree of Jesse*, one of Abbot Suger's windows in the chevet of St-Denis. The subject is taken from the Book of Isaiah in the Old Testament (11:1–2): 'And there shall come forth a rod out of the stem of Jesse, and a Branch shall grow out of his roots: And the spirit of the Lord shall rest upon him, the spirit of wisdom and understanding, the spirit of counsel and might, the spirit of knowledge and of the fear of the Lord.' This was a prophecy of the Christ who was to be descended from David, the son of Jesse.

The image, like that in many Gothic stained glass windows, is read from bottom to top. This is logical if we remember that anyone looking at the window is usually closer to the bottom than to the top. In the lowest panel of the window, Jesse lies sleeping on his bed. A lighted lamp indicates night. Out of Jesse's body grows a symmetrical tree, in whose branches appear five seated figures representing royal ancestors of Christ. In the curved panels on either side of the tree stand prophets with scrolls. At the top of the window sits Christ in Majesty, surrounded by doves symbolizing the Gifts of the Spirit enumerated by Isaiah.

In a long narrow window, it is obviously not possible to have the horizontal, sequential development of a narrative that would be

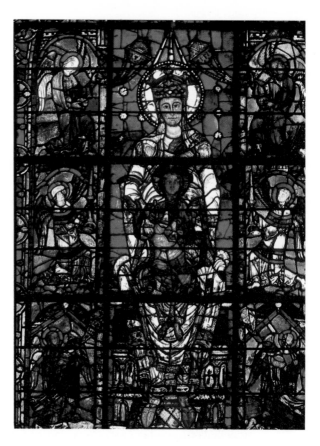

found in most manuscript illuminations; however, the shape is perfect for the presentation of such an image as the Tree of Jesse. And again, the brilliant translucence of stained glass is completely appropriate for the depiction of a prophetic vision.

THE LABYRINTH A curious feature of the interior of Chartres Cathedral is the circular labyrinth worked in the pavement of the nave. The geometry of the labyrinth is reminiscent of that of the rose window of the west façade. The medieval visitor could make a kind of symbolic pilgrimage to Jerusalem by negotiating the labyrinth on his or her knees. (Unfortunately, the labyrinth is not immediately apparent to the visitor of today because it is usually hidden by chairs.)

Drawing of the labyrinth, pavement of nave, Chartres Cathedral.

EXTERIOR OF CHARTRES CATHEDRAL From the outside, Chartres Cathedral appears much more massive than it does inside. In contrast to the deliberately flat and slender impression of the

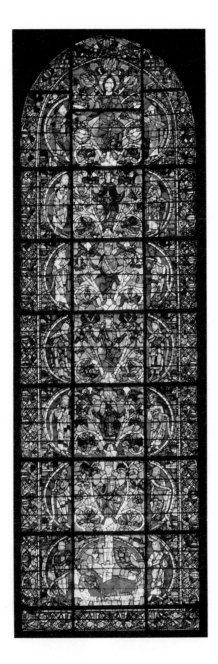

Tree of Jesse window,
west façade, Chartres
Cathedral, mid-12th
century.

interior walls, the exterior of the building projects and recedes
wherever possible. The great thickness of its walls is revealed by the
hooded mouldings around the windows. The heavy flying but-
tresses of the nave are shaped of stepped masses of masonry carrying
superimposed pairs of half-arches linked by squat colonnettes. The
eastern parts of the building were designed by someone other than

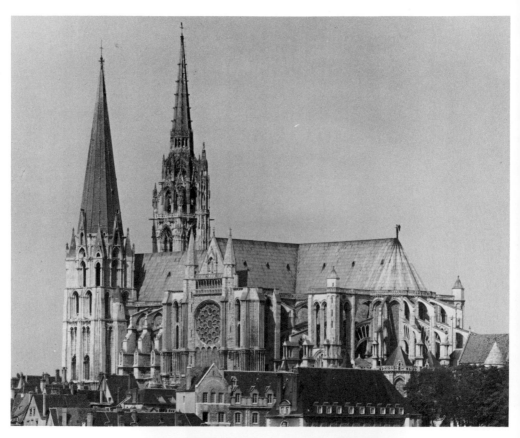

above
Chartres Cathedral from
the southeast.

right
Flying buttresses, nave,
Chartres Cathedral.

66

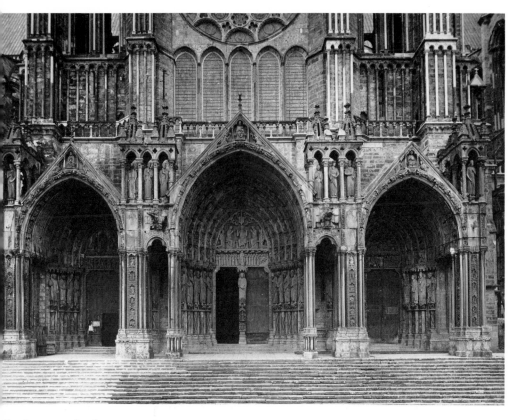

South transept façade,
Chartres Cathedral,
1200–20.

the master mason who planned the nave. This later designer liked lighter forms, as we can see from the view of the chevet. Even so, the bases of the towers flanking the transepts and the choir, and the flying buttresses are much bulkier than anything seen inside the cathedral.

THE TRANSEPT FAÇADES AND THEIR SCULPTURES This great three-dimensionality is apparent also in the design of the two transept façades, modelled on the west façade of Laon Cathedral (page 44). These transept façades were carved between 1200 and 1220. Each has three portals with porches. The layout of each portal conforms to an arrangement that became standard during the High Gothic period. Jamb-figures – statues similar to statue-columns, but more freely composed – flank the doorway proper. Above the jamb-figures are archivolts sculptured with figures. The archivolts frame a sculptured tympanum, now pointed rather than semicircular.

The handling of the jamb-figures is particularly instructive in

67

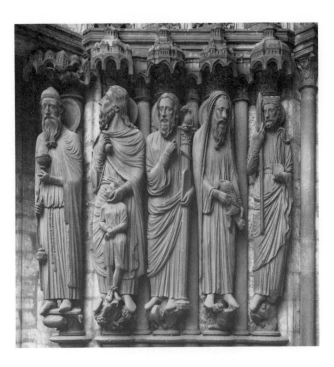

Melchisedek, Abraham and Isaac, Moses, Samuel, David, jamb-figures, lefthand side, central portal, north transept, Chartres Cathedral.

showing us what has become of Gothic sculpture in the half-century since the completion of the Royal Portal on the west façade. On the lefthand jamb of the central portal of the north transept, the jamb-figures depict, from left to right, Melchisedek, a priest; Abraham and his son Isaac; Moses with the Tablets of the Law; Samuel; and David. If we compare them with the statue-columns of the Royal Portal (page 40), we can see how much more lifelike the later figures are. Instead of appearing like relief sculpture rolled on to colonnettes, the later figures are nearly sculpture in the round, projecting strongly from the columns to which they are fastened. The figures of the Royal Portal rest their feet on simple conical supports. Here on the transept portal, each figure stands on a small sculpture, called a marmoset, that is related iconographically to the large figure. The transept figures turn their heads in different directions and move their arms away from their bodies. The draperies fall in simple but varied patterns; the faces are slightly differentiated from one another.

A new emotional subtlety parallels the physical animation. The group of Abraham and Isaac illustrates this quite beautifully. Abraham, who has made a covenant with God, has been commanded to make a burnt offering of his only son, Isaac, as a test of obedience to God. At the last moment, after Isaac has been prepared for ritual

68

slaughter, God sends an angel to prevent Abraham from killing his son. The angel shows the father a ram caught by its horns in a nearby thicket. The animal is sacrificed instead of Isaac. Here at Chartres, the sculptor tells this familiar Bible story in a remarkable way. Abraham, holding the sacrificial knife (the blade has broken off), stands listening to the angel of the Lord. Abraham's feet rest on a small ram caught in a Gothic thicket of stylized foliage. Little Isaac, his feet bound and his hands crossed in front of him, stands between his father's feet. Isaac's face is tilted up trustingly toward the angel. Although Abraham's expression is impassive, his tender cupping of Isaac's face with his left hand gives the key to the depth of human feeling between the pair. The gesture tells us how dear Isaac is to his father, and how great the demanded sacrifice would have been.

On the south transept of Chartres, the central portal depicts the Last Judgement, the most popular tympanum theme of the Gothic period. Last Judgement scenes were usually placed on the west façade, as at Conques (page 15), but the west façade of Chartres had already been decorated with the sculptures of the Royal Portal. The centrepiece of this Last Judgement is the tympanum, in which Christ sits enthroned in the heavens. On his right is the Virgin, interceding on behalf of sinners. Facing her is St John the Evangelist, also with his hands folded in a gesture of prayer.

Above and at each side of this central group are angels holding objects called the Instruments of the Passion, the implements with which Christ was tortured and killed. These include the column to which Christ was tied to be whipped, the lance which pierced his side, the cross on which he was crucified (the horizontal arm has been broken away), the Crown of Thorns, and the nails driven through Christ's hands and feet. The angels who hold the smaller objects do so with their hands covered with cloth. The idea behind this symbolism, which dates back to Byzantine art, is that the object is so precious that even an angel is unworthy of touching it with his bare hands.

On the lintel and in the archivolts, afterlife goes on. As we saw before at Conques, the depiction of blessed souls on the lefthand side of the lintel is rather placid and dull. But on the righthand side, the damned – whose ranks include royalty and monks – are punished by devils who throw naked souls into the Mouth of Hell

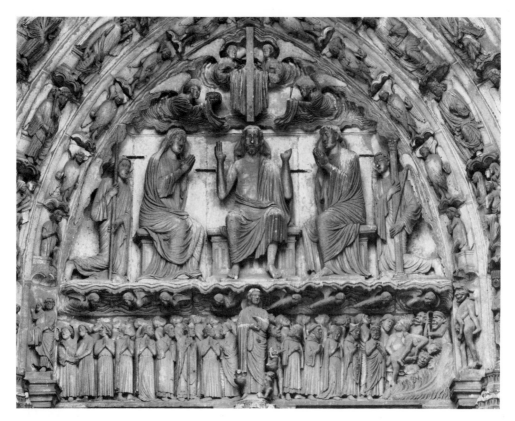

Last Judgement,
tympanum and
archivolts, carved
1230–50, central portal,
south transept, Chartres
Cathedral.

while flames lick about them. The archivolts are used here in quite
an interesting way, as extensions of the space of the lintel. At the
second level in the archivolts on both sides of the portal we see little
figures of resurrected men and women stepping uncertainly out of
their winding sheets and coffins. In the lowest level of the archivolts
on the lefthand side, saved souls are led away by angels. Abraham's
Bosom, a biblical image of heavenly rest, is interpreted quite
literally by the sculptor, who depicts the patriarch with a lapful of
three very blessed-looking souls. On the other side of the portal,
coarse little devils cart off sinners to hell. The two at the extreme
right are probably depictions of Lust, almost always a woman in
medieval art, and Avarice, traditionally shown as a man with a fat
money bag hanging around his neck.

In the lower zone of this portal, New Testament figures, instead
of the Old Testament ones seen on the north transept, fill the jambs
and trumeau. Christ as a teacher is the trumeau figure. The calm and
beautiful face is one of the high points of this phase of Gothic
sculpture. He tramples beasts beneath his feet in symbol of his

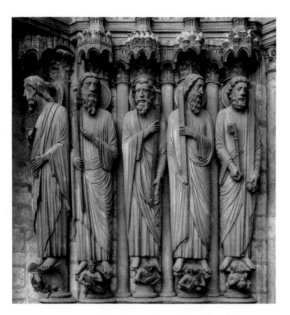

Disciples, Saints Matthew, Thomas, Philip, Andrew and Peter, lefthand jamb-figures, central portal, south transept, Chartres Cathedral.

power to overcome evil. (We saw the same symbolism in the reliefs of Sts James and Peter at the Porte Miègeville at St-Sernin in Toulouse, page 10.) The same sculptor who carved the Christ also carved the jamb-figures. They represent the disciples of Christ, five on each side, each standing on a marmoset figure of the person responsible for his martyrdom. The message is clear: at the Last Judgement only those are saved who adhere to the teachings of Christ and of his church.

These few examples from the sculpture and glass of Chartres Cathedral can only hint at the great variety of images that enrich this building. Their very diversity and comprehensiveness help us to realize that the medieval cathedral was regarded by contemporary people as an encyclopaedia of human and spiritual knowledge. Since not many people in those days could read, the planners of Chartres relied upon visual imagery to tell biblical stories, encourage faith, and teach doctrines. The power of visual images to affect people's thinking about matters that concern them deeply is easy for us to understand today with our experience of television and film.

REIMS CATHEDRAL: THE HARMONY OF HIGH GOTHIC

The master mason who planned the cathedral of Chartres had been the first designer to realize that the construction of flying buttresses

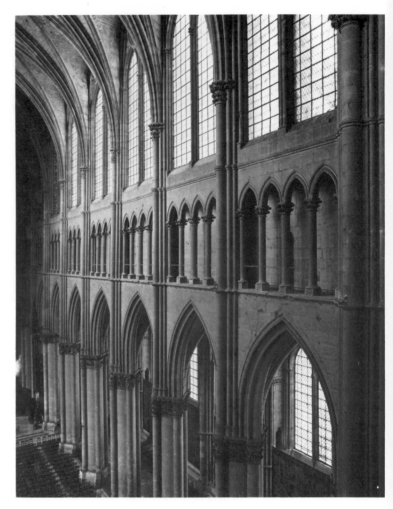

Cathedral of Notre-
Dame, Reims, begun
c. 1210.
Nave looking east and
plan.

0 25 m
0 75 ft

allowed him to omit the galleries, and to put up a wall elevation of
only three storeys that was also very tall. The simplicity of his
solution was so appealing that many other master masons of the
thirteenth century designed variations of Chartres. Of these, one of
the most satisfactory is the cathedral of Notre-Dame at Reims, an
easy day's horseback ride from Laon. The interior of Reims, begun
after 1210, makes an interesting comparison with that of Chartres
(page 61). Built according to similar plans, the basic disposition of
the elevations is also similar: a main arcade carried on massive piers
with engaged colonnettes, an unlighted triforium, and a tall
clerestory with paired lancets carrying lobed oculi.

But something has happened in the transmission of the design to
Reims. It has become more regular. The proportions of Reims are

72

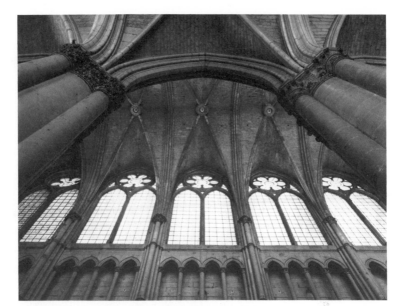

Vaulting in the nave,
Reims Cathedral.

different from those of Chartres. The vaults are 37.9 metres (124 ft
5 in) above the floor, little more than those of Chartres (36.5 metres,
119 ft 8 in); but because of the placement of the piers of the main
arcades, the nave of Reims appears to be significantly taller than that
of Chartres. Two other changes in these piers give regularity to the
overall design. The alternation of rounded and polygonal colon-
nettes and wall shafts that varied the nave design of Chartres has
been exchanged for uniformly cylindrical piers and colonnettes.
And the capitals are broad bands of foliage proportional to the
overall bulk of the piers. The grave majesty of this architecture is
highly appropriate to the cathedral in which traditionally the kings
of France were anointed.

Harmony and regularity also characterize the design of the west
façade of Reims. Comparison with the west façades of Laon and
Paris and the transept façades of Chartres (pages 44 and 67) allows
us to see the directions in which French Gothic façades developed
during the course of the thirteenth century. Like all of the other
structures mentioned, the façade of Reims has three portals opening
into the principal spaces of the interior, jamb-figures and sculptured
archivolts, a rose window above the central portal, and twin towers
without spires. Unlike the façade of Laon, the nearest neighbour,
that of Reims is cleanly marked by continuous horizontal and
vertical subdivisions. Such a regular, grid-like design in a Gothic
building is sometimes called a 'harmonic façade'. Instead of three

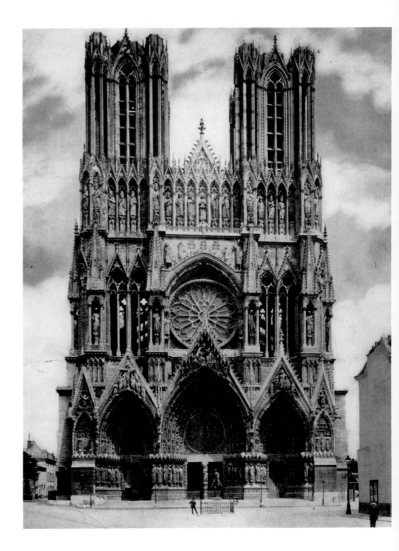

West façade, Reims
Cathedral.

tympana filled with sculpture, each of the portals at Reims has a rose
window fitted within the space enclosed by the archivolts. The rose
windows are filled with a new kind of tracery, called bar tracery,
consisting of intersecting ribwork made up of slender shafts (as
opposed to plate tracery, in which openings are cut out of a solid
shape, as in the west rose of Chartres). In contrast to the flat, serene
façade of Notre-Dame in Paris, that of Reims looks three-
dimensional and almost lacy. Pointed shapes abound – there are
even two extra gables bracketing the three portals. The bases of the
two towers are pierced by many traceried openings. And the tops of
the towers, though lacking proper spires, have so many little gables
and pinnacles that they resemble crowns.

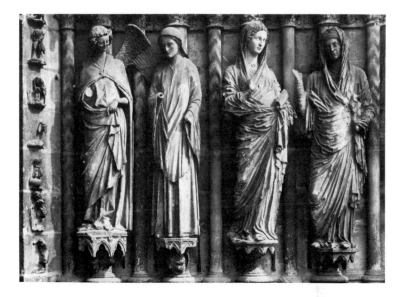

Annunciation and
Visitation, jamb-figures,
righthand side, central
portal, west façade,
Reims Cathedral, carved
1230–50.

WEST FAÇADE SCULPTURES: THE ANNUNCIATION AND
VISITATION At the righthand side of the central portal are two
groups of sculpture, an Annunciation and a Visitation. These are
interesting for several reasons. If we compare this group of four
jamb-figures, which were carved between 1230 and 1250, with the
group of Old Testament figures from the north transept portal at
Chartres (page 68) made before 1205, we see several significant
differences. One is that the figures at Reims seem even less
dependent upon their architectural setting than those of Chartres.
They stand on small pedestals that jut out abruptly from the jamb,
and do not appear to be related precisely to the slender colonnettes
behind them. At Chartres, each large figure is independent from its
neighbour; at Reims, however, the four figures are placed so as to
form two pairs of figures.

Another contrast is that the Chartres figures seem to have been
made by the same sculptor, while those at Reims are clearly the work
of a group of artists whose styles differed slightly. Though these
sculptors' names are lost to us, we can learn something of their
professional identities by analysing their work. Elizabeth and the
Virgin of the Visitation, the two figures at the right, wear similar
robes which fall in narrow, trough-like folds reminiscent of the work
of Nicholas of Verdun. Each woman stands with her weight mainly
on one leg, the upper part of her body twisted toward her
companion. Elizabeth, the older woman, is correctly shown with a
wrinkled face that contrasts with Mary's youthful beauty.

75

When we turn to the Annunciation figures, we find quite a different treatment of draperies and faces. The angel Gabriel, at the left, wears robes that fall in broad, diagonal loops and pile up around his ankles, as though they were somehow too big for him. His face is different from anything else we have encountered in Romanesque or Gothic art, for he is smiling, with apple cheeks and laugh lines around his eyes. The smile, however, is due less to his delight in telling good news to the Virgin Mary, than to the creation by French artists at this point in the thirteenth century of a stylized facial expression to indicate beauty and blessedness. We see it in many sculptures of the period, and it has come to be called 'the Gothic smile'. By contrast, the face of the Virgin Mary next to Gabriel is rather block-shaped and blank. Her eyes and mouth are not much more than simple incisions into the mass of the stone. The draperies fall in columnar, vertical folds that end at her feet. A few shallow 'V'-shaped folds are used in the mantle covering the upper part of her body. This figure was made by yet another sculptor. Although the three sculptors of these four figures remain anonymous, one has been given a name. The creator of the angel Gabriel also carved a figure of Joseph that stands across the portal from our group. From this the artist has been called the Joseph Master of Reims. The custom of naming artists for their best-known works is used by art historians as an aid to classification of objects during periods like the Gothic in which so many works are anonymous.

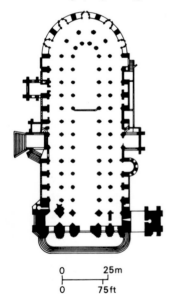

Cathedral of St-Etienne, Bourges, begun 1195.

0 25m

0 75ft

ST-ETIENNE AT BOURGES: A DIFFERENT SOLUTION

Some French Gothic cathedrals of the thirteenth century look very little like the cathedral of Chartres. Its most famous contemporary is the cathedral of St-Etienne (St Stephen) at Bourges, situated south of Paris, approximately in the geographical centre of France. This cathedral was begun in 1195, a year after the beginning of reconstruction at Chartres.

When we compare the plans of Chartres (page 60) and Bourges, we find that the latter has a double aisle that goes all the way around the building, and no transept. The interior of Bourges is like a great tent, with its lateral spaces spreading lower and broader than the

76

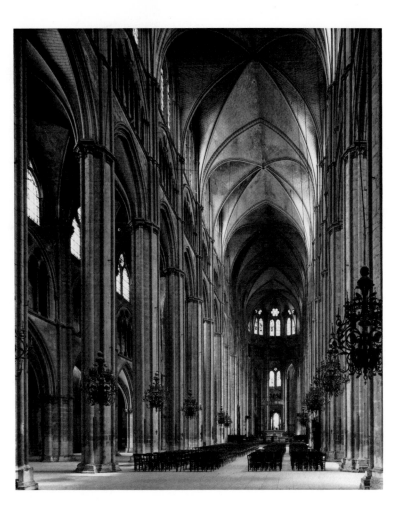

St-Etienne, Bourges.
View from the west end
and (*below*) transverse
section.

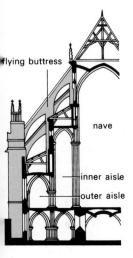

peak of the main vaults. The elevation of the nave has three storeys,
but their proportions are quite different from anything we have seen
up to this point. The main arcade is gigantic, taking up over half of
the height of the interior. The triforium and clerestory are almost of
the same height as each other. The sequence of main arcade,
triforium and clerestory is repeated in the elevation of the inner aisle
which comes up to the height of the main arcade of the nave. The
outer aisle, in turn, rises only to the height of the main arcade of the
inner aisle. The cross-section drawing makes this relationship clear.
The colonnettes used in the piers and in the triforium are very
slender, so that the overall structure of the interior, while unified,
does not seem to be monumental.

The same spirit of delicacy characterizes the exterior. Because of
the double aisle, the flying buttresses had to be doubled as well,

77

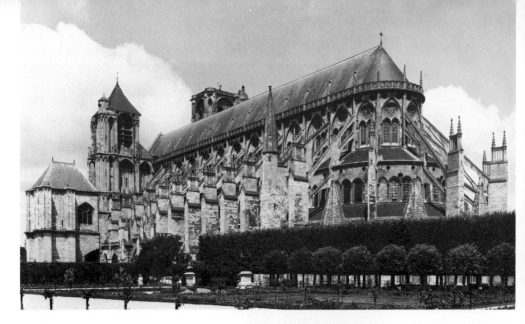

above
St-Etienne, Bourges,
from the southeast.

right
Sainte-Chapelle, Paris,
1243–6.

below
Shrine of St Taurinus,
cathedral of St-Taurin,
Evreux, copper and
silver gilt with enamel
plaques, mid-13th
century.

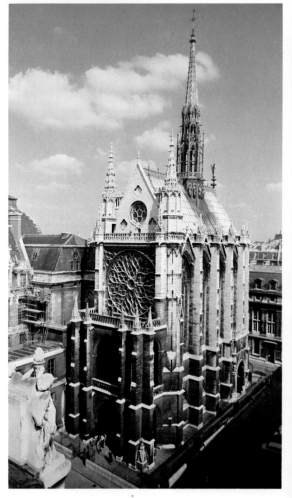

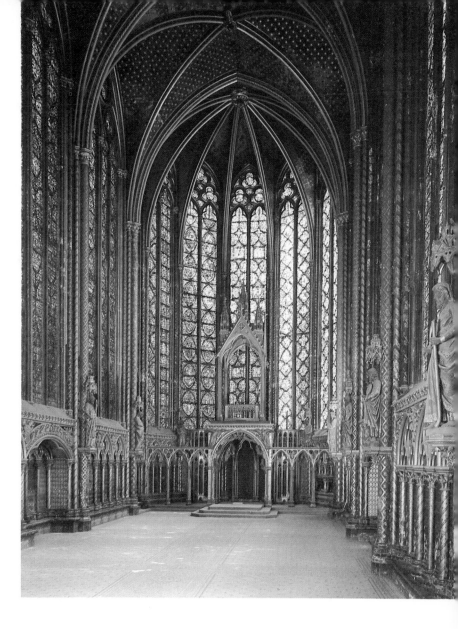

Upper chapel looking east, Sainte-Chapelle, Paris.

making two 'leaps' before coming to rest. The sweep of their airy forms is especially impressive when the cathedral is viewed from the southeast.

THE SAINTE-CHAPELLE AND THE RAYONNANT STYLE

The main form of the French Gothic style of the second half of the thirteenth century is called Rayonnant. The name means 'radiating' in French and comes from the radial spokes of bar tracery in the

79

great rose windows of the period. Walls became thinner and thinner, with only slender colonnettes interrupting the glazed areas of the building. Increasingly, the characterization of a Gothic building as a stone cage became appropriate.

One of the finest examples of the Rayonnant style is the little chapel of Louis IX of France (1214–70) built between 1243 and 1246 in the royal palace in Paris. The chapel is known as the Sainte-Chapelle – the Holy Chapel. The king, better known as St Louis, had the chapel built to house the Crown of Thorns and a fragment of the True Cross that he had bought from the Byzantine Emperor while on a crusade. Whatever we think now of the gullibility of the period (for surely no crown made of thorns could have lasted for thirteen centuries), we are impressed by Louis's political shrewdness and by his taste in architecture. The idea behind the building, as stated by a contemporary pope, was that Christ had crowned Louis with his crown. And what Louis built was a sort of brilliant, large-scale reliquary.

Comparison with a more typical reliquary of the period, the copper, silver-gilt and enamel shrine of St Taurinus, makes this clearer. The shrine was made around the middle of the thirteenth century for the cathedral of St-Taurin at Evreux in Normandy, to house the relics of its patron saint. This reliquary, which stands about 70 cm (28 in) high, looks like a tiny Gothic building with towers, gables, openwork pinnacles, sculptured figures, and other ornament. The figures and some of the decorative sections are done in a technique called repoussé in which the design is hammered out from behind against a hollow mould. Enamel and precious stones adorn the surface of the shrine.

The Sainte-Chapelle was originally much more ornamented, and resembled such a shrine more closely. The masonry was gilded. There were frescoes with gilded backgrounds that imitated metalwork designs. Statues were placed along the side of the building, between the windows. Even more evocative of the colourful brilliance of contemporary reliquaries is the effect of the stained glass which almost completely filled the spaces between vertical supports. The windows are tall and slender, with newly complex tracery patterns, as delicate as the patterns used in metalwork at the time.

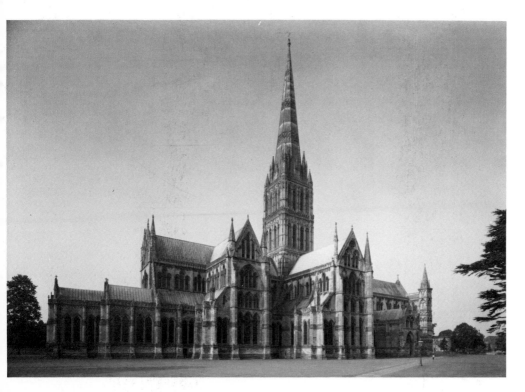

Salisbury Cathedral
from the northeast,
begun 1220.

SALISBURY CATHEDRAL: A UNIFIED DESIGN

Unlike French cathedrals, which were frequently built on high ground in densely populated cities, the cathedral of Salisbury in southwestern England was begun on a plain, away from existing settlements. According to legend, the site was decided upon either by the fall of an arrow shot from the ramparts of a nearby castle, or by a dream in which the Virgin ordered Bishop Richard Poore to build at the spot where the cathedral now stands. Construction of the main body of the church was carried out between 1220 and 1262. Because its planners did not have to accommodate themselves to an existing building, as at Chartres, the design of the cathedral is unusually cohesive. Salisbury is a fine example of the Early English style.

From the outside the cathedral appears as a long, low building with a central crossing tower (added in the fourteenth century). The building is set off by a five-fold base moulding that continues without interruption around the exterior, incorporating the buttresses, almost like a Greek temple. The west façade is designed to screen the internal subdivisions of the building, unlike the harmonic

West façade, Salisbury
Cathedral.

façades typical of contemporary French Gothic, whose compart-
ments indicate the spatial arrangement inside the building. Three
tall lancets light the west end of the nave, and three portals, the
central one taller than its companions, give access to the church.
Two small spires top the right and left edges of the façade, but there
is little visual emphasis to suggest that these are significant towers,
as they would have been on a French building. Instead, the entire
façade of Salisbury is subdivided into horizontal bands of niches,
most of which contain sculpture. Unlike French cathedrals, the
portals are not decorated with sculptured figures.

The plan of Salisbury is also quite different from French
cathedral plans. A comparison with the plan of Reims, the nearest
contemporary to Salisbury that we have looked at, is instructive.
Both plans are based on crosses. Both buildings make use of four-
part rectangular vaults to cover the main spaces. At Reims, the
chapels are arranged radially around the ambulatory, as we have
seen in almost all of the French examples. The transept projects
only slightly and then flows into the double aisle of the choir. But the

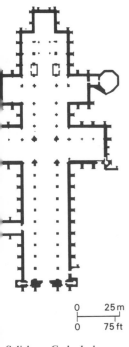

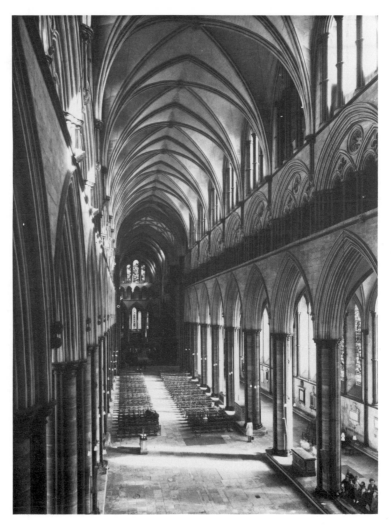

Salisbury Cathedral,
plan and nave.

Salisbury plan has two transepts and a square east end. Both
transepts have aisles only on their eastern sides. At the eastern end of
the building is a small chapel called a Lady Chapel, dedicated to the
Virgin, patroness of the cathedral. Such Lady Chapels are common
in English Gothic buildings.

The interior of Salisbury is distinctively English in character. In
spite of the ribbed vaults, pointed arches, and tracery, the building
looks very different from French Gothic buildings; there is much
more emphasis on horizontal elements. The spandrels between the
arches of the main arcade are unmarked by wall shafts. The
triforium openings are broad, each composed of two pairs of two
arches encompassed by an arch that is almost round. As in the choir

83

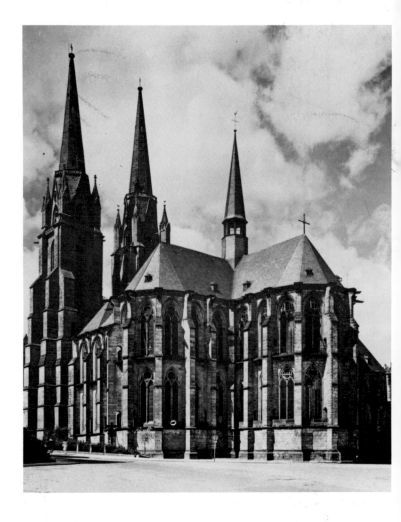

St Elizabeth, Marburg,
from the southeast,
1235–83.

of Canterbury (page 49) there are multiple dark colonnettes of
Purbeck marble which contrast with the pale limestone. Another
characteristically English feature is the multiplicity of mouldings
surrounding the arches, especially in the main arcade and triforium.
Everywhere the tracery and arches have been laid out according to
precise geometry, so that the interior design is even more effective
when we face the walls than when we look down the length of the
nave.

ST ELIZABETH AT MARBURG: GERMAN GOTHIC

Germany, too, developed a national version of the Gothic style in
the thirteenth century. The first clear example is found in the

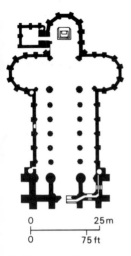

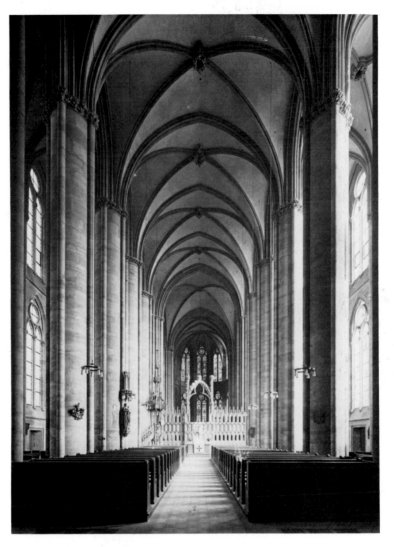

St Elizabeth, Marburg,
plan and nave looking
east.

church of St Elizabeth at Marburg on the Lahn, southeast of
Cologne. Construction began in 1235 and ended in 1283. A nave of
six bays precedes a trefoiled east end. Each transept arm is the same
length as the choir, and all three of these structures are apsidal – that
is, curved, rather than square-ended – in plan. Apsidal transept
endings are a characteristic of many earlier Romanesque churches in
Germany. St Elizabeth also revives a type called the 'hall church'
that was popular in earlier German architecture. This is a church
whose aisles are the same height as the nave, as opposed to a basilica,
whose aisles are lower than the nave. Thus, there are no windows in
the central nave of St Elizabeth. The elevation has a single tall

85

arcade carried on piers with delicate foliate capitals. The aisles are two storeys high, lighted by two levels of tall windows whose simple bar tracery reminds us of the design of Reims Cathedral. A feature that differentiates St Elizabeth from French Gothic buildings of the same time is the absence of flying buttresses, unnecessary here because the aisles are the same height as the nave. The resulting exterior design is compact but delicate because of the repeated verticals of the standing buttresses and the regularity of the two storeys of traceried windows.

MANUSCRIPT ILLUMINATION: 'THE HEAVENLY JERUSALEM'

In the twelfth century, when the most important artistic centres were monastic ones, large-format Bibles and theological commentary had been the kinds of book most likely to receive lavish decoration. In the thirteenth century, as the centres of artistic production passed more and more into the hands of lay people and as more members of the nobility became interested in using and owning books, new kinds of book became popular. Many of these were relatively small volumes, meant to be used by an individual. Some of the more common types of book were psalters; Books of Hours, which were private prayer books devised for the use of specific people; bestiaries, which told facts and fables about animals; collections of Lives of the Saints; and Apocalypses, which contained the Book of Revelation from the New Testament.

Another thirteenth-century manuscript type was a moralized Bible. In previous Bibles, the entire text had been written out and illuminations put in at relatively few points. By contrast, the planners of a moralized Bible made selections of texts to be illustrated and commented upon, in some instances apparently choosing passages because they lent themselves readily to illustration. The moralized Bible illustrated here, called the Toledo Bible, is essentially an extremely luxurious picture book, its richness appropriate to the high social standing of its original owner, Queen Blanche of Castile. This page, from the Apocalypse portion of the Bible, depicts St John's vision of the heavenly Jerusalem, recounted in Revelation 21.

opposite
'The Heavenly Jerusalem', Toledo Bible fol. 5 v, The Pierpont Morgan Library, New York, MS 240, *c*. 1226–34.

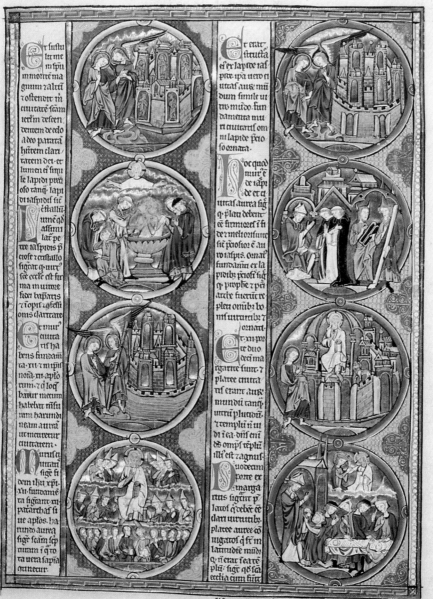

glificata ūindigebit oratione.

The layout of the page in two columns of four units each is characteristic. A paragraph of text stands just at the left of a roundel containing a visual interpretation of the words. These text-and-picture units are arranged in pairs that are related to each other – for example, the two uppermost pairs of the righthand column of the page illustrated belong together. The Latin inscription at the top reads: 'And it [the city wall] was built of jasper and the city itself of pure gold, just like pure glass. The foundations of the walls of the city were adorned with all kinds of precious stones.' In the accompanying miniature, we see an angel pointing out a turreted, walled heavenly Jerusalem to St John. The city wall is painted green, the colour of jasper. In the lower roundel, a seated bishop addresses two monks. We can identify the bishop by his mitre, a shield-shaped crown, and the monks by their tonsures, shorn rings of hair symbolizing the Crown of Thorns. At the right of this group is Moses. He is easily recognized by the horns sprouting from his head (the result of a defective translation of biblical Hebrew into Latin at an early date) and by the tablets he is holding, on which the Ten Commandments were written. At the extreme right is a bearded figure whose pointed hat identifies him as a Jew. Here the text explains, first, that the wall of jasper and the city of gold signify that prelates should be very firm in their faith and of great value, just as the jasper and gold are precious, and secondly, that the adorning of the foundation means that the prophets and patriarchs were filled and adorned with all good virtues. The uppermost inscription follows the text of the Apocalypse fairly closely, while the second statement suggests an interpretation of it by drawing a parallel between the heavenly Jerusalem and the religious men.

Just as, when we looked at the Sainte-Chapelle, we were reminded of goldsmiths' work, so we can see some similarities in the design of this manuscript page to the designs of stained glass windows of the thirteenth century. For example, see the Tree of Jesse window in the west front of Chartres Cathedral, page 65. Some of the similarities include the layout of the page in parallel columns of small round shapes, the use of simple geometric patterning called diapering in the background surrounding the roundels, and the basic colour scheme based on blue and red. But some aspects of the moralized Bible page are characteristic of

manuscripts alone: the harmonious balance of text and visual image; the creation of brilliance with gold leaf rather than with transmitted light; and the virtuoso performance of the miniaturist who has worked on such a small scale with such precision.

We see quite a different artistic approach to St John's vision of the heavenly Jerusalem in the picture illuminating a page of the Trinity College Apocalypse, probably painted sometime between 1242 and 1250. The manuscript text is a condensed French translation of a Latin commentary on the Apocalypse by a writer named Berengaudus. The prominence of women in many of the illuminations of the manuscript suggests that it was probably made for a noble lady, possibly Queen Eleanor of Aquitaine (1122?–1204).

In the Trinity College Apocalypse, the heavenly Jerusalem is the only image on the page. At lower left, an angel points toward the city while grasping St John by the wrist. The spiritual intensity of his vision is emphasized through several compositional devices. The most important of these is the radial symmetry of the heavenly city. Following earlier visual tradition, especially that of tenth-century Spanish manuscripts, the city is projected flat, with its four groups of three gates equidistant from the central square. In its upper lefthand quadrant we see Christ in a mandorla, accompanied by a lamb and a book on which is inscribed 'AMEN' – 'So be it'. The rest of the square is partially filled by an angel with a measuring rod, a river of fire and a flowering tree. None of these figures or objects seems truly three-dimensional, nor does any of them cast a shadow to confirm for us its position in space. By suppressing specific suggestions of depth and by emphasizing the abstract, schematic nature of the design, the artist helps us to understand that this is a vision of the eternal majesty of God.

Another device that enhances the visionary quality of the miniature is its colour. The predominant hues are strong reds and blues. But more important here is the use of gold leaf, especially for the background of the central square. Gold is precious in many cultures because of its beauty and rarity, and it has often been associated with power and social or religious importance. We have already seen several medieval objects made largely of gold (e.g. the reliquary of Ste Foy, the Klosterneuburg Altar, the shrine of St Taurinus). Almost from the beginnings of Christian art, artists also

used gold in two-dimensional media like mosaic to create backgrounds for Christ and other important holy figures (e.g. page 22). Not only did gold imply wealth, but also it was often used in Christian art to symbolize light, especially in visual styles in which the artist's control of modelling had not developed very fully. In the Trinity College Apocalypse illumination, gold serves both purposes. The artist has used the gold field to help us understand that the images of the central square belong to heaven, an otherworldly place of reward where all is bright, clear, and in every way superior to earth.

The gates of the heavenly city are formed like miniature Gothic portals, with pointed gables and small projections that look like the

battlements of a castle. Over the gates are written the names of the twelve tribes of Israel. The city walls are made of layers of different colours in which the names of the twelve apostles are written. This arrangement helps the artist to stress the correspondence between the Old and New Testaments.

Although the organization of this page is very different in many ways from the image of the heavenly Jerusalem seen in the moralized Bible, there are some stylistic qualities shared by the two manuscripts that help us to recognize them both as mid-thirteenth-century Gothic. An obvious similarity is the depiction of con-temporary Gothic architecture. Another similarity is the graceful yet active figure-style, with its agitated poses and gestures, draperies arranged in broad folds, and high-domed heads with curly hair. Another common feature is the consistent colour-scheme based on red, blue and gold, with only small areas of other colours. In both works, the artists have attempted to represent individual objects three-dimensionally. Yet, as we saw previously in Romanesque art, there is still no consistent attempt to place groups of figures within spaces that are deep or tall enough for them. The Gothic figures differ from their Romanesque predecessors in having more contour lines, more modelling in the draperies, proportionately larger heads, and softer facial expressions.

THE NAUMBURG CHOIR FIGURES AND GOTHIC NATURALISM

Throughout the Gothic and later periods, it was common for artists to represent figures in contemporary dress. This was done in part because most artists had no way of knowing what the costumes of previous eras had looked like, and in part because artists wished to present figures and events as vividly as possible. Contemporary dress made the depicted figures seem to exist among the people of the artist's own time – as though a twentieth-century artist were to represent Christ as a teacher wearing a turtleneck sweater and a tweed jacket.

The practice of using 'modern' dress was followed in the retrospective portraits of benefactors of the cathedral of Naumburg placed in its west choir. This mode of dressing figures is only one

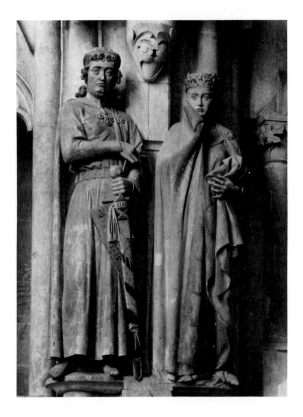

Ekkehard and Uta, west choir, Naumburg Cathedral, after 1249.

aspect of a general trend toward realism in art that developed around the middle of the thirteenth century. Two of the Naumburg figures, Ekkehard, Margrave of Meissen (1032–46), and his wife, Uta, are illustrated here. These lifesize painted 'portrait' statues were done after 1249 by a sculptor known to us only as the Master of Naumburg. Ekkehard and Uta had been dead for two hundred years, but this master made such realistic images that they are probably likenesses of another man and woman. Ekkehard is represented as a portly, middle-aged man with a great mass of curly hair, wrinkles, and several chins. He wears a voluminous cape over a long belted robe. Through its folds, we can see that most of his weight rests on his left leg. With his left hand, Ekkehard grasps a sword, which rests in front of a shield on which his name is painted. He reaches across his body with his right hand to lift the hem of his cape. This gesture is quite casual, compared with the formality of earlier Gothic sculpture, and gives Ekkehard great physical immediacy. Uta, too, seems caught in a momentary pose. She turns her face to our left, away from the main axis of her body. Gathering up the folds of her cape under her left arm, she uses her right arm to

muffle her cheek in a gesture that conveys regal but modest reserve. The sculptor's suggestion of the shape of Uta's forearm and hand beneath the woolly cape is an astonishing invention, more evocative of a real person's movements than almost any other gesture we have seen so far.

SUMMARY OF HIGH GOTHIC ARCHITECTURE AND ART

The High Gothic style of the thirteenth century is one of poise, especially in architecture. The simple three-storey wall elevation of Chartres Cathedral provided a model followed by many master masons of the period. With the conquest of height achieved through hard-won expertise in engineering, builders refined architectural proportions to give structures even greater apparent height. The Rayonnant style, named for the radiating bar tracery of its rose windows, appeared about the middle of the century in France.

Sculpture also attained a moment of equilibrium in its blend of idealization and detail observed from nature. The most character-istic sculpture of the century is the jamb-figure of the Gothic portal, now animated by a more lifelike articulation of anatomy, by the beginnings of individualized facial expressions, and by a more imaginative handling of the rhythms and patterns of draperies.

This is also the century of stained glass and of brilliant manuscript illumination. Deep-toned glass is an integral part of the effect of the High Gothic cathedral, whose pale stone surfaces are softened and modulated by the changing light as it moves over them. Individual windows with their complex iconographical pro-grammes contribute to the wealth of symbolism of the cathedral. Manuscript illumination, an art which flourished because more and more people wanted books, is newly sumptuous, with abundant gold leaf and rich colours. Delicacy of line, graceful figures, and attempts to represent three-dimensionality make this period a high point in the production of beautiful books.

4 Late Gothic architecture and art

During the twelfth and thirteenth centuries, when almost one-third of the population of Europe was French, it was natural for the works of highest quality to have been produced in France. By the fourteenth century, with the shifts and losses in population caused by multiple wars and the Black Death (a massive outbreak of fatal bubonic plague that reached Europe in 1348), people were so widely scattered throughout the Continent that artists were active in many countries, working for people whose lives had undergone profound changes that influenced what they wanted to see around them.

In comparison with the patterns we have seen in the twelfth and thirteenth centuries, fewer great architectural enterprises were undertaken in the fourteenth and fifteenth centuries. Although architects and masons were still kept busy building for the wealthy, people were often interested in smaller projects, such as sculptural groups, manuscripts, panel paintings and tapestries. Buildings of the fourteenth and fifteenth centuries, while still decorated, were less frequently planned with such elaborate schemes of sculpture or glass as were High Gothic structures. Sculpture and painting, in their turn, were much more likely to be made as objects to stand or hang by themselves, as more and more people began to take an interest in commissioning and possessing them.

People also began to recognize the individual achievements of artists and architects to a much greater extent. Although the makers of earlier Gothic art and architecture were by no means all anonymous, the identification by name of an individual is the exception rather than the rule during the twelfth and thirteenth centuries. The surviving evidence of contracts, payrolls, guild rosters and other late Gothic documents indicates, however, that the recording of artist's names with their works became much more important than it had been in earlier centuries. This is the case even if we allow for the fact that the older the document the greater the accumulated risk of its chance destruction by decomposition, fire or

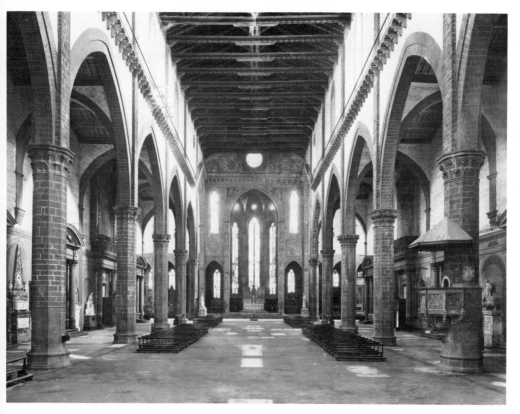

Nave looking east,
Santa Croce, Florence,
by Arnolfo di Cambio,
begun 1294.

human carelessness (for example, Parisian butchers in later centuries occasionally used Gothic manuscript pages to wrap meat).

Whereas the cruciform basilican cathedral with sculptured portals and stained glass windows was the chief building type of the High Gothic period, buildings with different functions are more characteristic of the two following centuries. Some of these buildings are ecclesiastical, while others are secular.

SANTA CROCE, FLORENCE: A FRANCISCAN PREACHING CHURCH

Saint Francis of Assisi (1181/2–1226) founded a religious brotherhood called the Franciscan order. From the beginning, the Franciscans have always insisted upon remaining poor in worldly goods and upon preaching to ordinary people. These ideals are reflected in one of the most important of the Franciscans' churches, Santa Croce (Italian for 'Holy Cross') in Florence. Construction

95

began in 1294, probably under the direction of a prominent Florentine sculptor and architect named Arnolfo di Cambio (died *c.* 1302), and continued well into the fourteenth century. Santa Croce has a timber-roofed nave of seven bays. A polygonal apse is separated from the nave by a triumphal arch something like those found in Early Christian basilicas of the fourth to sixth centuries. This form, like some of the Romanesque portals discussed in chapter 1, derives ultimately from the monumental triumphal arches of ancient Rome. Here at Santa Croce, the triumphal arch is pointed and is pierced by two pointed windows.

The structure is almost a hall church, with only slender octagonal piers separating nave from aisles. The main arcade is tall, and the clerestory is rather small, so that the interior gives an impression of loftiness and openness, but not of the verticality characteristic of French versions of the Gothic. This design was planned deliberately, so as to create a low, broad interior with relatively few internal obstructions. The advantage to effective preaching is obvious: large crowds are able to see and hear easily. The relatively austere aspect of the interior is in keeping with the Franciscan tradition of poverty and in strong contrast to the Late Gothic style that flourished in fourteenth-century England.

GLOUCESTER CATHEDRAL: THE PERPENDICULAR STYLE

The interior of the choir of Gloucester Cathedral (1337–*c.* 1355) is one of the earliest examples of the English version of the Late Gothic style, called Perpendicular. The name derives from its predominantly vertical and horizontal tracery bars. Other characteristics of the style include the use of slender, vertically subdivided supports and large windows (Gloucester's east window is the largest in England); window tracery with little fantasy or inventiveness; and the panel motif, repeated in rows and tiers throughout the tracery design. What we see in the photograph is actually a screen of 'modern' Perpendicular tracery applied to the inside of an already existing Norman building.

The vaulting is of a new type sometimes called a net vault, which incorporates lierne ribs (from the French *lien*, meaning a tie or

opposite
Choir and east window,
Gloucester Cathedral,
1337–*c.* 1355.

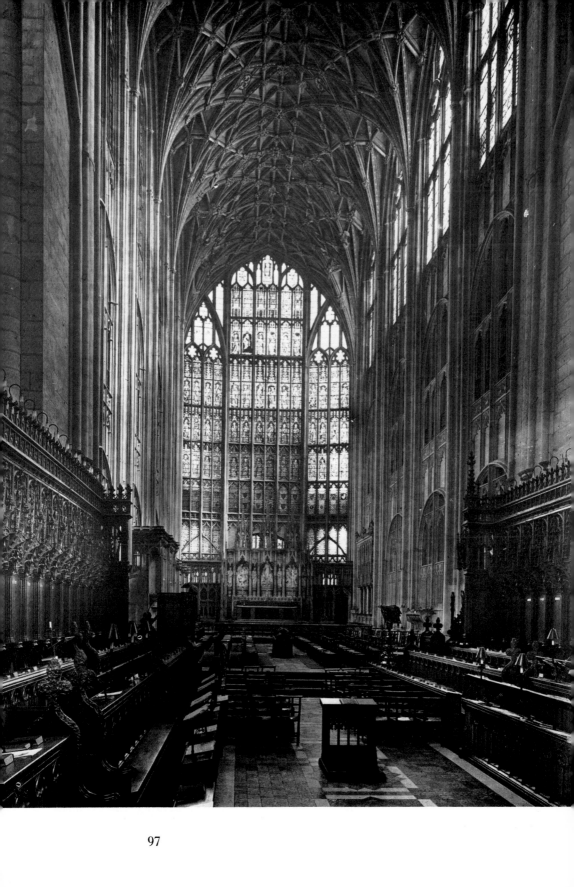

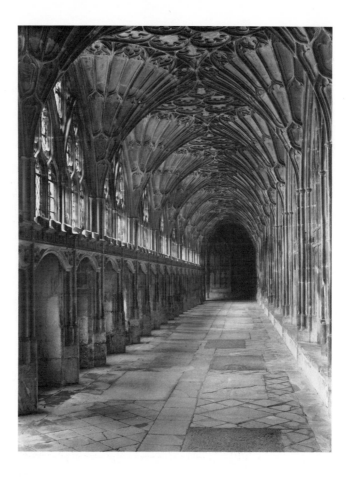

South walkway of
cloister, 1351–77,
Gloucester Cathedral.

bond). A lierne is any rib other than one lying along the ridge of a
vault which does not start from the springing of the vaulting
compartment. Liernes are typically short, profuse, and decorative.
Here at Gloucester they form curved triangles, quadrangles,
pentagons and hexagons in the vault with such complexity that the
bays merge completely, making the vault look like a continuous
surface. This design emphasizes the unity of the interior space, and
may remind us of the unified interior space of Santa Croce.

The walkways of the cloister at Gloucester, built between 1351
and 1377, are covered with yet another new kind of vaulting, called
fan vaulting. The 'fans' are halves of funnel shapes, concave in all
vertical sections but convex in all horizontal sections. The bays are
nearly square. Intermediate ribs have become so numerous that the
masons found it expedient to carve ribs and webbing from the same
large block of stone, instead of constructing ribs and webbing
separately. The result is an undulating flow of space from bay to bay.

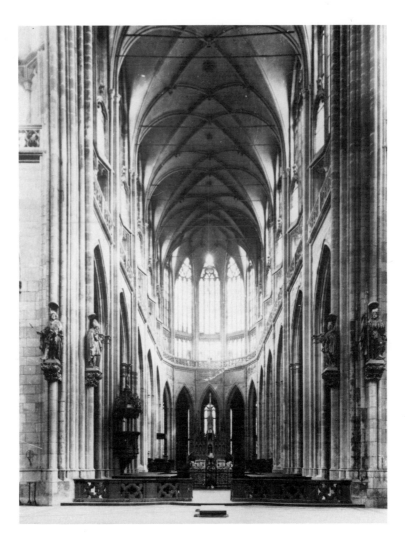

Interior of chevet, by Peter Parler, cathedral of St Vitus, Prague, founded 1344.

PETER PARLER AND THE CATHEDRAL OF ST VITUS IN PRAGUE

At the other end of Europe was Prague, seat of the imperial court of Emperor Charles IV (1346–78), head of the vast political domain called the Holy Roman Empire. It was he who ordered the construction of St Vitus Cathedral, inviting as its first architect a Frenchman, Matthias of Arras. The plan of St Vitus is French: its chevet is composed of choir, ambulatory and radiating chapels, much like Chartres or Reims.

But the upper parts of the chevet, as well as much of the rest of the cathedral, are the work of Peter Parler, a member of a famous German family of master masons. Parler was called to Prague after

above
Triforium and clerestory, chevet, St Vitus, Prague.

above right
Self-portrait of Peter Parler, triforium, choir, St Vitus, Prague.

the death of Matthias of Arras in 1352. By 1374 he was able to begin work on the triforium. This is glazed, and so appears to be almost an extension of the great clerestory. The apparent reduction of the elevation of the choir to two storeys, instead of the more traditional three, is characteristic of the trend toward unification of elements seen in much of later Gothic church design. In both triforium and clerestory are elements set out diagonally against the piers, giving the choir design a unique flavour. The diagonal elements in the clerestory are small windows with trefoil tracery surrounded by arches decorated with little foliate ornaments called crockets. Below are obliquely set sections of wall to which are applied a series of bust-length sculptured portraits of benefactors of the church, including the likeness of Peter Parler, which may be a self-portrait. The vaulting of the choir, completed by 1385, is a net vault that unifies the entire vault surface in a continuous pattern. The close resemblance of Parler's designs to the sort of vaulting seen at Gloucester suggests strongly that he may have seen masons' drawings of fourteenth-century English vaults.

TWO CHAPELS

King's College Chapel, built between 1446 and 1515, is the chapel of the college of that name within the University of Cambridge in

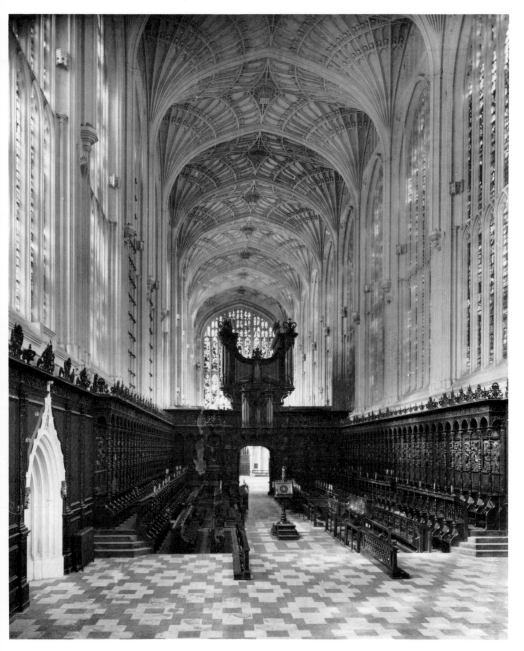

Chancel looking west,
King's College Chapel,
Cambridge, 1446–1515.

England. One of the last ecclesiastical buildings of the fifteenth
century to be built in the Gothic style, the chapel was designed for a
community of scholars, rather than for a monastic community, royal
court, or country or city parish. Although the original effect of the
Perpendicular interior has been altered by the addition of a large

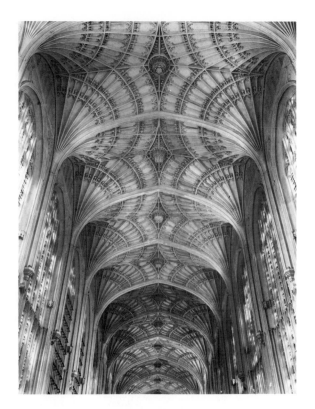

Vaults of King's College
Chapel, Cambridge, by
John Wastell.

organ screen, we can see that the aisle-less nave and choir of twelve
rectangular bays form a perfectly proportioned single space. The
beautiful fan vaults were designed by John Wastell, a master mason
whose name first appeared in the records of King's College Chapel in
1486, and who died in 1515. The vaults were partly constructed with
traditional ribbed vaults, in which ribs and webbing are put up
separately, and partly in the same way as the cloister at Gloucester,
where the surface of the fan vault is treated like relief sculpture, with
ribs and webbing carved from the same block of stone.

The Chapel of the Constable at the east end of the cathedral of
Santa Maria at Burgos, in northern Spain, was designed at almost
the same time (1482–94) as the vaulting of King's College Chapel.
The master mason was Simón de Colonia (died *c.* 1511), son of a
German master mason named Juan de Colonia (Hans of Cologne)
who had come to Burgos to work on the cathedral, bringing with him
building ideas from the north of Europe. Yet, by the time the son set
about designing the octagonal funerary chapel for Pedro Hernandez
de Velasco, hereditary constable of Castile, the result was peculiarly
Spanish.

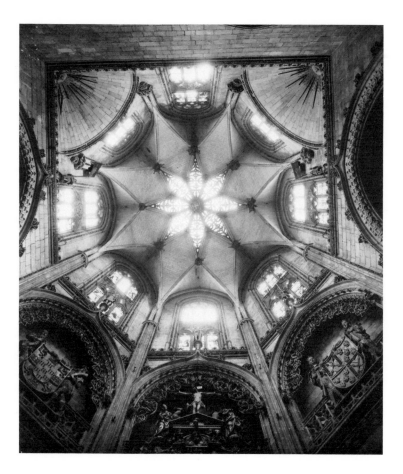

Vault, Chapel of the
Constable, cathedral of
Santa Maria, Burgos, by
Simón de Colonia,
1482–94.

The vault crowning the chapel is an eight-pointed star remi-
niscent of Islamic star vaults, composed of interpenetrating ribs
which define sections of smooth webbing. These in turn surround
an inner star ornament with an open network of curving tracery of a
type called Flamboyant (French for 'flaming'), because of the
resemblance of its curves to curling flames. Ornamental projecting
keystones, bearing coats of arms, accentuate the points of the inner
star and its centre. The deliberate contrast of rich ornamentation
and a neutral surrounding area is especially characteristic of Spanish
taste.

PRIVATE DWELLINGS

One of the clearest symptoms of the shift in patronage from the
Church to the laity in the Late Gothic period is the construction of

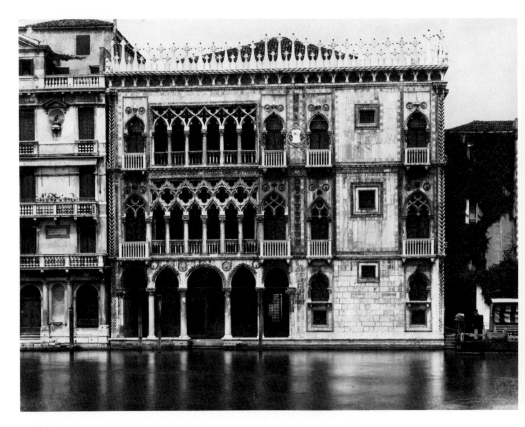

Ca' d'Oro, Venice, by
Matteo Raverti,
1422–40.

more secular buildings of high quality. Two examples of private
dwellings from the first half of the fifteenth century are the Ca'
d'Oro in Venice (1422–40) and the House of Jacques Coeur in
Bourges (1443–51).

The Ca' d'Oro, or House of Gold, takes its name from the rich
painting and gilding which once adorned the white limestone
façade. The palace, built by Matteo Raverti for the Contarini
family, is considered the most beautiful Gothic building in Venice.
Its design, like everything else built in the city, was conditioned by
the fact that Venice is constructed on pilings in the middle of a tidal
lagoon. Land is quite scarce, and almost all local travel is by water.
The Ca' d'Oro fronts directly on the Grand Canal (the Venetian
equivalent of Fifth Avenue in New York or the Champs-Elysées in
Paris). There is no hint of military defence in the welcoming
arrangement of the façade of the palace. What we see of it today is
only two-thirds of what was originally intended. The open section
that is now the lefthand half was designed to be a middle section,
flanked by matching corner blocks. The lowest level of this lefthand

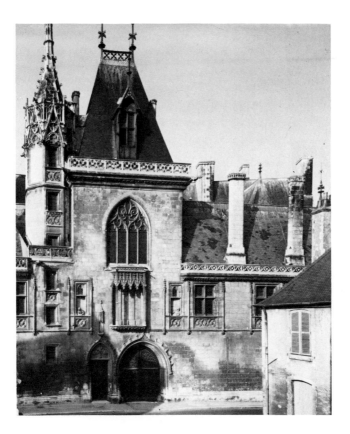

Street façade, House of
Jacques Coeur, Bourges,
1443–51.

section is the entrance portico, to which boats, rather than horses, brought residents and visitors. Stairs lead up to the principal living level, placed safely above the water line.

The symmetry of the façade seems quite appropriate when we realize that the architect, like most designers in Venice, seems to have calculated the appearance of the reflection of the façade in the canal as part of the ultimate effect of the design. Other aspects typical of the Gothic architecture of Venice are the variations in rhythm and interval of the elements (for example, in the central section, there are five arches at water level but eight in each of the two upper storeys), the contrast of open and closed masses of the building, the arches with a reverse curve like Islamic arcading, the cusping of arches, and the proliferation of quatrefoils.

We see a very different interpretation of the Late Gothic private residence in the House of Jacques Coeur. Its builder was Jacques Coeur (*c.* 1395–1456), a highly successful treasurer of King Charles VII of France and ambassador to the papal court. By special permission, the house was built against the city wall of Bourges, and

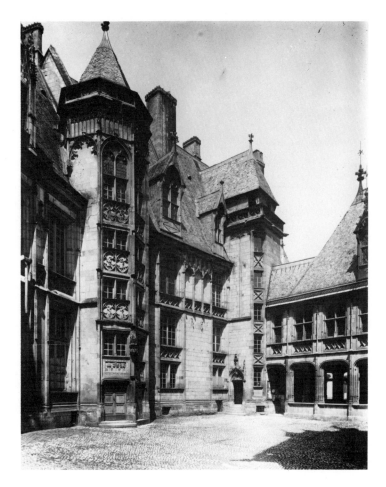

Courtyard, House of
Jacques Coeur, Bourges.

incorporates several of its defence towers. Above the main entrance
on the street façade is a chapel. At either side of this are relief
sculptures of Jacques Coeur and his wife. The rest of the house is
arranged around a large courtyard. The most prominent feature of
its rear wing is a great polygonal stair tower, which gives access to
each storey. Rooms were set along the other wings of the courtyard
to suit the convenience of the Coeur family and their large
household.

The different widths of the various parts of the building result in
roofs of different heights. The general impression given by the
design is of irregularity and freedom, rather than the formal
symmetry and regularity of design of the Ca' d'Oro. The handling of
window and wall design also makes an interesting comparison.
Whereas in the Ca' d'Oro, the elaborate tracery above windows and
other openings lends the façade the air of being wrapped in lace,

most of the windows in the House of Jacques Coeur are simply large rectangles, each divided into four sections by intersecting mullions and transoms. Most of the wall surfaces of this building are flat, with linear mouldings and tracery carved in low relief concentrated along the edges of forms, while at the Ca' d'Oro the wall surface is varied by means of strong contrasts of coloured materials, and by projection and recession of mass.

LATE GOTHIC SCULPTURE: GIOVANNI PISANO

Giovanni Pisano, *Virgin and Child, c.* 1305–6, marble, height 129 cm, Arena Chapel, Padua.

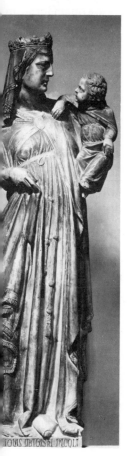

Just as the architecture of the fourteenth and fifteenth centuries was usually planned without sculpture, painting or stained glass as an integral part of the design, so most of the sculpture of the period is not attached to buildings, though many sculptures were placed in architectural contexts. Such a work is the marble *Virgin and Child* by Giovanni Pisano (*c.* 1245/50–after 1314) that stands on the altar in the Arena Chapel in Padua, near Venice.

Like many Italian works of the Middle Ages, this group owes much to the artist's experience of seeing Greek and Roman art. The Virgin and Child are smaller than lifesize. Yet, it is central to Giovanni Pisano's artistic conception that the sculpture is free-standing, existing in the same space as ourselves, rather than presenting the illusion of space implied in relief sculpture. As we have seen, such free-standing works are rarer in the Romanesque and the earlier phases of the Gothic periods than relief works attached to architecture. Free-standing figures are, however, quite normal in Greek and Roman sculpture.

Other clues that Giovanni Pisano had studied ancient sculpture are the stance and facial type of the Madonna. In contrast to the typical Romanesque Madonna, usually shown seated quite formally, symmetrically and even sternly with a rigid infant on her regal knees, Giovanni Pisano's Virgin, wearing a crown over her veil, stands holding the Child on her arm. We notice that it is her left arm. This seems to be not so much a matter of artistic tradition as a result of the artist's observation of life. He must have seen mothers carrying around small children in such a way as to leave their right hand free to perform other tasks. Mary's right arm rests against her

body. She holds up the hem of her mantle so that soft, diagonal folds cascade down her side. These contrast with the parallel, column-like folds that fall away from her knotted belt. The sloping angle at which this belt lies around her waist, the tilt of her shoulders, and her left foot emerging from beneath the hem all tell us that most of her weight is borne on her left leg, and that the upper part of her body assumes an 'S'-curve beneath its drapery. This compensatory shifting of the weight of the torso is sometimes called by the Italian word *contrapposto* – 'counterpoise' – and is a marked feature of many Greek and Roman sculptures of the human figure. The face of Giovanni Pisano's Queen of Heaven is serious and austere. There is no Gothic smile here, but rather a typically Roman face, with a long straight nose, prominent brow and heavy jaw.

But other elements of the style of the sculpture are pure Gothic in their gracefulness. Look at the place where the Child's and the Mother's bodies touch. The easiest way for a mother to carry an infant of this size would be either to hold him close to her breast with his face turned toward her, or else to perch him along one side of her body, with his legs straddling one of her hips and her arm supporting his back. But this is art, not life; and Giovanni Pisano, wishing to arrange his two figures so that both could be seen equally, has the Virgin hold Christ rather far out to her left side, in the crook of her arm, a posture that would become extremely tiring if maintained for long. Christ's posture is also unusual. His right arm rests companionably over his mother's shoulder, as he appears to chat with her, while his left arm lies quietly along his left thigh. He seems almost too well behaved to be a convincing representation of a small child, and yet his cheeks are chubby and his proportions properly baby-like. He appears to be the beloved baby of a very aristocratic mother.

'THE VIRGIN OF JEANNE D'EVREUX'

A slightly different mother-and-son relationship is suggested by the small silver-gilt repoussé statue called the *Virgin of Jeanne d'Evreux*. It was presented by Queen Jeanne d'Evreux, the widow of Charles IV of France, to the abbey of St-Denis in 1339. Again, the Virgin

holds the Christ Child on her left arm. In her right hand is a sceptre topped by a jewelled fleur-de-lys, the stylized lily that for centuries symbolized the French monarchy. A depression running around the Virgin's veil shows where a crown once rested, indicating that, in spite of the human sweetness of her face, this image depicts Mary as the Queen of Heaven. Christ, too, exhibits a mixture of human and kingly qualities. His extremely chubby cheeks indicate how young he is. With his right hand, he reaches up to pat his mother gently on the cheek. But in his left hand he holds a little sphere, called an orb, an ancient symbol of earthly power.

An understanding of the sculptural technique used here helps to explain why this piece looks elegant but artificial. The stone sculptures we have seen up to this point were carved out of solid materials. Carving is a process of revealing a shape by taking away from a block of stone or wood what is not wanted. But one can also make sculpture by other techniques: modelling, the process by which clay is worked; casting hot metal in a mould; and beating metal, as was done to make the *Virgin of Jeanne d'Evreux*. The significant thing is that the figure is hollow. We can sense this in the relationship between the drapery and the underlying human forms. In contrast to the figure of the Virgin by Giovanni Pisano, which seems to have existed first as a solid mass, and then to have had draperies arranged over it, the *Virgin of Jeanne d'Evreux* looks more like a set of artfully arranged stiff draperies out of which emerge only the head, hands and feet of a woman and a small baby. The tall, narrow, slightly top-heavy silhouette of the sculpture and the brilliance of its gilded surface increase the impression of its being something quite otherworldly.

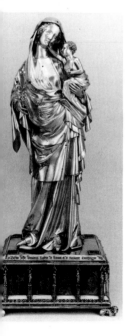

Virgin of Jeanne d'Evreux, 1339, silver-gilt, height 69 cm, Louvre, Paris.

LATE GOTHIC MANUSCRIPTS: 'THE HOURS OF JEANNE D'EVREUX'

By the fourteenth century, commissions for large-scale paintings in northern Europe were rather rare. Once in a while someone ordered a set of wall paintings – the most famous of the period in France being the frescoes decorating the study of Pope Clement VI (1342–52) in the papal palace at Avignon – or commissioned a

stained glass window for an existing church. Much commoner by the Late Gothic period were requests for illuminated manuscripts and small easel pictures painted on wooden panels. Surviving records frequently allow us to identify the names of patron or artist, and sometimes both.

A Parisian manuscript, 'The Hours of Jeanne d'Evreux', was illuminated by Jean Pucelle in a technique called grisaille (from the French *gris*, or grey). All but a few coloured accents of the image are painted in shades of grey, so that the figures look like stone. The manuscript is a Book of Hours, a group of prayers intended for private devotions, rather than for communal masses. This tiny example was apparently painted for Queen Jeanne d'Evreux in the years between her marriage to Charles IV in 1325 and his death in 1328.

The righthand page of the frontispiece of this Book of Hours, shown here, depicts two separate scenes, one above the text and one below, as well as a kneeling figure in the initial word of the text that may represent Queen Jeanne herself, with her lapdog at her feet. The principal image is the Annunciation. The subject matter of the lower scene is unrelated to the religious theme. Instead, the artist has depicted a completely secular medieval game called 'Frog in the Middle', in which players leap about hitting the one who is 'it', who sits cross-legged on a cushion, like a frog. A small separate scene like this at the bottom of a manuscript page is often called a *bas-de-page* – French for 'bottom of the page'. The inclusion of such scenes was an especially strong tradition in the manuscript art of the Netherlands. Although we are not sure where Jean Pucelle came from originally, he seems to have brought that tradition with him to Paris.

An important aspect of Pucelle's style is his mode of representing the depth. We can see this most clearly in the Annunciation, which takes place in the Virgin's house. Its front wall has been omitted, so that we see the angel Gabriel, kneeling at the left and raising his hand in greeting to the Virgin, who stands in the slouch that by now has become characteristic of the mature Gothic style. Pucelle has modelled the figures by means of broad areas of light and shade, rather than by means of line alone. Only such details as faces, hair and hands are given precise outlines. The lines representing architectural forms 'behind' Gabriel and the Virgin are arranged so

Jean Pucelle,
Annunciation, from
'The Hours of Jeanne
d'Evreux', 1325–8,
grisaille and colour,
9 × 6 cm, The
Metropolitan Museum
of Art, New York,
The Cloisters Collection,
purchase 1954.

that they converge, rather than run parallel to one another. This system of suggesting the illusion of the third dimension on a two-dimensional surface is sometimes called linear perspective. It was to become an increasingly common feature of Late Gothic painting.

Not all Late Gothic manuscripts were religious. One secular work that was copied a number of times was 'De claris mulieribus', by the Italian writer Boccaccio, a collection of biographies of famous women that was a companion volume to a collection of biographies of famous men. A French translation of the treatise, 'Des cleres et nobles femmes', was given as a New Year's Day present in 1403 to Philip the Bold, Duke of Burgundy (1342–1404), the younger brother of King Charles V of France. The manuscript was illuminated by an artist known to us only as the Coronation Master, whose professional training seems to have been Netherlandish

One of the famous women included in Boccaccio's work was Marcia, a woman painter from Classical times. In the illustration we

Coronation Master, Marcia Paints her Portrait, 'Des cleres et nobles femmes', fol. 101 v, Bibliothèque Nationale, Paris, fr. 12420, before 1403.

see her engaged in painting her own portrait. She works with the aid of a mirror, as must anyone wishing to depict his or her own features. Marcia sits on a yellow chair in front of an easel. On it rests a panel bearing her portrait-in-progress, a frontal view of her squat face and blond hair. By modern standards, she seems too elegantly dressed to be at work as a painter. At the left is a trestle table on which Marcia's paints and brushes are laid out. Blue, red, yellow, and white pigments sit ready in their containers. The same colours are laid out on her scalloped palette, giving us a glimpse into the working procedure of a fifteenth-century artist. Marcia herself bends over her work, a little person with slumped shoulders, apparently intent on creating her self-portrait.

By now we have grown accustomed to seeing images of women in Gothic art. But they have usually been women whose importance is defined by their relationship to specific male figures. They are wives or mothers, often idealized, of famous men or boys. But Marcia is interesting both as an artist at work and as a woman appearing in her own right and painting her *own* portrait, rather than that of some important patron.

THE UNICORN TAPESTRIES: 'THE UNICORN IN CAPTIVITY'

One of the curious things about art is that it does not always make logical progress forward as technology does. By this time artists in Flanders and in Italy had discovered how to suggest in painting three-dimensionality or the effects of natural light. The story of how they did this is part of the history of Renaissance art. This book concludes with a beautiful example of a work designed by an artist who, though he probably knew of the new discoveries, did not choose to employ them. *The Unicorn in Captivity*, one of the most appealing images of Late Gothic art, is the final scene of a set of seven tapestries made around 1500.

The unicorn is a mythical creation of the medieval imagination, a wild, cloven-hoofed horse with a goat's beard and a long, spiralling horn. The popular belief was that the only way to hunt a unicorn was for a virgin to sit in the forest as bait until the unicorn came along and went to sleep with his head in her lap. In this tapestry, the elegantly collared unicorn, captured by hunters, lies on a flowery lawn inside a small pen. He is chained to a pomegranate tree, a traditional symbol of fertility and also, because it contains many seeds in one fruit, of the church. The unicorn, who was rather badly battered in earlier tapestries of the series, now looks quite serene, in spite of his wounds. He has sometimes been interpreted as a symbol for the resurrected Christ.

In order to appreciate *The Unicorn in Captivity*, it helps to understand a little about the tapestry medium, which was extremely popular at the time this work was undertaken. Tapestries usually served to decorate large, otherwise bare, stone walls in aristocratic dwellings and churches. These hangings cut down draughts as well, for they were closely worked in warm, absorbent wool and silk. Typically, they were woven from large-scale preparatory paintings called cartoons that were usually placed behind the warp (the fixed threads running lengthwise in the loom as opposed to the weft or woof, the coloured threads carried back and forth on shuttles). Unlike painters, who worked in a fluid medium that could be mixed as they went along, weavers had to plan and prepare their colours before beginning work. This entailed having all the threads dyed, mostly with vegetable dyes, to match the colours in the cartoon.

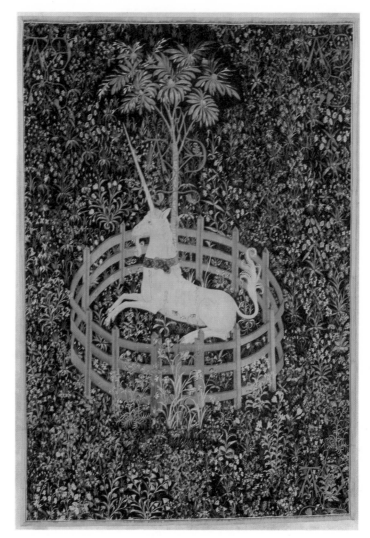

The Unicorn in Captivity,
c. 1500, tapestry,
368 × 251 cm,
The Metropolitan
Museum of Art, New
York, Gift of
John D. Rockefeller, Jr.,
The Cloisters Collection,
1937.

Many weavers were needed to produce each tapestry, because of such factors as the fineness of the work (there are between 13 and 21 warp threads to the inch in the Unicorn Tapestries), the necessity of starting and stopping the bobbins carrying different colours, and the large scale of the typical tapestry.

Part of the unicorn's charm lies in the deliberate visual ambiguity of the image. We know that the tapestry is physically flat, and that it was conceived as decoration for a wall surface. The area surrounding the white unicorn is a dark green sown with multicoloured flowering plants. These are treated almost two-dimensionally, as decoration. The unicorn, too, with its beautiful flowing profile,

appeals purely as two-dimensional patte
to be rearing. Yet, at the same time, *i*
dimensional image, he appears to be lying down. ⸱ ⸱
of the pen corroborates this perception of the unicorn. Such tⲟⲛⳑ
between the depiction of depth and space, on the one hand, and
elegant two-dimensional design on the other is nothing new in
Gothic art. *The Unicorn in Captivity* is representative of its period in
its designer's favouring of two-dimensional considerations over
three-dimensional ones.

SUMMARY OF LATE GOTHIC ARCHITECTURE AND ART

By the fourteenth and fifteenth centuries, Gothic architecture began
to acquire distinctive regional and national characteristics. Less
obsessively tall structures, vast but unified interiors, and fascination
with the decorative possibilities of new vaulting forms characterize
many Late Gothic buildings.

The great works of sculpture of this period are not usually
attached to architecture. Many of them are free-standing figures
that exhibit the graceful, exaggerated curve called the Gothic
slouch. Faces have become more feminine. Artists combine an
elegance of line with close observation from nature of surface
textures and of human anatomy.

In painting, many of the same stylistic features may be seen.
Manuscript illuminators have become more skilful in representing
the illusion of three-dimensional space, and in emphasizing stylized,
flowing silhouettes, which are highly decorative and even sensuous.

In all areas, Late Gothic art manifested a greater emphasis on
individual, as opposed to collective, enterprise. And there was a shift
toward the greater inclusion of secular life as fit material for art, a
shift reflecting yet another change of attitude that was to bring about
a Renaissance of culture and a Reformation of religion in sixteenth-
century Europe.

Glossary

ABBEY the religious body of monks or nuns governed by an abbot or an abbess; also, the buildings used by it.

AISLE area flanking nave, choir, or transept of a church, generally separated from it by an arcade.

AMBULATORY an aisle curving around the apse or hemicycle.

APOCALYPSE (adj. APOCALYPTIC) the Book of Revelation, the last book of the New Testament, traditionally attributed to St John the Evangelist.

APSE semicircular or polygonal termination of a church or chapel, usually containing an altar.

ARCADE a row of arches supported on piers or columns.

ARCH a construction used to span an opening, composed of wedge-shaped blocks of masonry.

ARCHIVOLT the moulding on the face of an arch, surrounding its contour; may be multiple.

ARTICULATION the subdivision of a wall surface, by means of openings, and horizontal and vertical projections.

ATTRIBUTE in art, an object held in a figure's hand or regularly associated with it (e.g. St Peter's keys).

AXIS an imaginary line or lines about which a work, a group of works, or part of a work is visually or structurally organized, often symmetrically.

BARREL VAULT a continuous semicircular or pointed vault resting on walls; an arch extended sideways.

BAS-DE-PAGE a small scene placed at the bottom of a manuscript page, often with subject matter unrelated to the principal scene depicted on the page.

BASILICA a church divided into a nave and two or more aisles, the former higher and wider than the latter, lit by the windows of a clerestory (cf. HALL CHURCH).

BAY internal compartment of a building, defined by vertical projections on the side walls or by transverse divisions of the vault or roof; in Romanesque and Gothic churches the transverse arches and piers of the arcade divide the building into bays.

BENEDICTINE ORDER the monastic rule founded by St Benedict of Nursia (c. 480–547/50) at Subiaco, near Rome.

BOOK OF HOURS a book for private devotions containing prayers for the different canonical hours of the day (matins, vespers etc.). Books of Hours frequently contained a calendar illustrated with the Labours of the Months.

BREVIARY a book containing the offices to be said by the clergy at the canonical hours.

BUTTRESS vertical mass of masonry or brickwork built against a wall to give support.

BYZANTINE referring either to the Greek city of Byzantium (now Istanbul), or to the Byzantine Empire (fourteenth–fifteenth centuries), its art, culture etc.

CAPITAL the upper member of a column; it serves as a transition from the shaft to the load that it supports.

CARYATID a sculptured female figure used like a column.

CATHEDRAL a bishop's church (from *cathedra*, a bishop's throne); the principal church of a diocese.

CENTERING a wooden framework used to support an arch or vault during its construction.

CHAMPLEVÉ a process of enamelling in which a design is cut into a metal plate in such a way as to leave thin raised lines that create compartments to hold the enamel.

CHEVET the eastern complex of a church, usually composed of the apse, ambulatory and radiating chapels.

CHOIR the part of a church near the main altar, usually at the east end, where divine service is sung. In the Gothic period, the straight bays preceding the eastern apse.

CISTERCIAN ORDER a stricter branch of the Benedictine order, established in 1098 at Cîteaux, France.

CLASSICAL 1. of, pertaining to, or characteristic of Greek and Roman antiquity; 2. (cap.) pertaining to or designating the style of the fine arts, especially painting and sculpture, developed in Greece during the fifth and fourth centuries BC, chiefly characterized by balanced composition, the separation of figures from an architectural background, and the naturalistic rendering of anatomical details, spatial

movement, and distribution of weight in a figure; 3. pertaining to or designating a phase of a later style, such as Gothic, which exhibits qualities similar to those described in 2.

CLERESTORY the part of the nave wall, lit by windows, that rises above the level of the aisle roof.

CLOISONNÉ a kind of enamel work in which the surface decoration is set in hollows formed by thin strips of wire welded to a metal plate in a complex pattern.

CLOISTER square court surrounded by a covered arcaded passage, usually adjoining a church and linking it with monastic buildings.

COLONNETTE a small column.

COLUMN cylindrical support, usually consisting of base, shaft and capital.

CROCKET a projecting foliate ornament of a capital, pinnacle, gable, buttress or spire.

CROSSING space at the intersection of the nave, transepts and chevet of a church.

CRUSADE any of the military expeditions undertaken by Christians from the end of the eleventh to the end of the thirteenth centuries to recover the Holy Land from the Moslems.

CRYPT the semi-subterranean storey of a church where relics were usually kept.

CUSPS projecting points formed at the meeting of curves of tracery.

DIAPERING all-over surface decoration composed of a small repeated pattern, such as lozenges or squares.

DRAPERY the artistic arrangement of folds of clothing.

EARLY CHRISTIAN the style-name given to art and architecture of the Late Roman period made for Christian purposes (approximately first–fifth centuries AD).

EARLY ENGLISH the style-name given to early Gothic architecture in England, c. 1170–1240, characterized by lancet windows.

ELEVATION 1. one side, or face, of a building; 2. a representation of the upright portions of a building in which every part of every feature is indicated as though seen at eye-level (cf. SECTION).

EMBRASURE a flared frame around a doorway or window.

ENAMELLING fusion of powdered glass on a metal surface at high temperature.

EVANGELIST SYMBOLS symbols of the authors of the four Gospels: angel, Matthew; lion, Mark; bull, Luke; eagle, John.

FAÇADE exterior face of the west end or transept end of a building, often decorated with sculpture.

FAN VAULT a vault consisting of solid concave-sided semi-cones, meeting or nearly meeting at the apex of the vault. The cones and centres are decorated with panelling so as to give the appearance of a highly decorated ribbed vault.

FLAMBOYANT the style-name given to the latest phase of French Gothic architecture, originating from the undulating, flame-like shapes in the window tracery.

FLYING BUTTRESS an arch rising from a wall buttress to rest against the clerestory at the point where the vault begins.

FOUR-PART VAULT a ribbed vault, square or oblong in plan, carried on two intersecting diagonal arches; that is, composed of four separate compartments.

FRANCISCAN ORDER a mendicant order founded in 1209 at Assisi in Italy by St Francis of Assisi (1182?–1226).

FRESCO painting on wet plaster; the pigment is mixed with water so that it may form a bond with the plaster.

GABLE triangular upper part of a wall at the end of a pitched roof.

GALLERY upper floor above (and as wide as) the aisles of a church, with openings into the main body of the building.

GOSPELS the first four books of the New Testament, which recount the life of Christ and are traditionally ascribed to Matthew, Mark, Luke and John.

GOTHIC SLOUCH the exaggerated curve of standing figures in Gothic art, especially of the thirteenth century and later.

GOTHIC SMILE a stylized smile invented by thirteenth-century artists, in which not only are the corners of the mouth upturned, but also the eyes are narrowed, and the skin beside the eyes and the lower eyelids is puckered.

GRISAILLE a monochrome painting done mainly in neutral greys to simulate sculpture.

GROIN VAULT vault formed by the intersection at right angles of two barrel vaults.

HALL CHURCH church in which the aisles are approximately the same height as the nave (in contrast to a BASILICA, in which the nave is taller than the aisles).

ICONOGRAPHY the symbolic, often religious meaning of objects, persons, or events depicted in works of art.

ILLUMINATION decoration with drawings, usually in gold, silver, and bright colours, especially of the initial letters of a manuscript.

INTERNATIONAL STYLE style in painting and sculpture popular between c. 1375 and c. 1425, characterized by fluid curvilinear patterns, soft pictorial qualities, and great attention to the observation of natural detail.

JAMBS the sides of a doorway or window; often splayed to accommodate decoration, especially figural sculpture.

KEYSTONE central or topmost voussoir in an arch.

LABOURS OF THE MONTHS depictions of human occupations typical of each month of the year, often in the cosmological schemes on sculptured portals of

cathedrals and churches, and in calendars in liturgical manuscripts.

LADY CHAPEL a chapel dedicated to the Virgin, usually built east of the choir and forming a projection from the main building; in England, it is normally rectangular in plan.

LANCET narrow window with a pointed arch and without any subdivision.

LIERNE a short rib that runs from one main rib of a vault to another.

LINTEL stone laid horizontally across an opening.

MAIN ARCADE the ground-floor level of the wall elevation of a medieval nave, transept or choir.

MANDORLA 'Almond' in Italian; an almond-shaped halo of glory used around a figure of God, Christ, the Virgin Mary, or other holy person.

MARMOSET a small sculpture placed beneath the feet of a jamb-figure as its support.

MASONRY anything constructed of stone (or brick or tiles), usually involving mortar; especially walls or vaults of stones that have been shaped or dressed.

MEDIUM the physical material with which an artist works; also, the fluid in which pigment is suspended to make paint.

MODELLING 1. in painting, the indication of solid form and receding planes in a three-dimensional representation. 2. in sculpture, the shaping of three-dimensional forms in a soft material such as clay.

MODULE the basic unit of measure determining the major subdivisions and proportions of an object, figure, building or site.

MONASTERY the dwelling place of a community of monks.

MONUMENTAL of sculpture or painting, large in size; also in art criticism, any work of art of unpretentious grandeur and simplicity, regardless of its size.

MORTAR a material consisting of lime, water and sand used to bind together stones or bricks so that the mass may form one compact whole.

MOSAN referring to the region of the valley of the Meuse River, especially its southern section, in northeastern France and southern Belgium. The term 'Mosan art' usually refers to the art of the twelfth and thirteenth centuries.

MOULDINGS continuous contours forming ridges or grooves, given to projecting architectural members.

MULLION projecting upright shaft dividing a window into a number of 'lights'.

NARTHEX a large enclosed porch or vestibule of a church at the main entrance.

NAVE the main body, or middle part, lengthwise, of a church interior, extending from the principal entrance to the choir or chancel. Normally the nave is flanked on either side by aisles.

NET VAULT a vault which incorporates lierne ribs.

NORMAN the style-name given to Romanesque architecture in the areas ruled by the Normans, especially England after 1066.

OCULUS 'eye' in Latin; a round window.

PATRON a person, usually a wealthy and influential one, who sponsors and supports a person, activity or project.

PERPENDICULAR the style-name given to English Late Gothic architecture (c. 1350–1530); derived from the vertical and horizontal bars of the window tracery.

PERSONIFICATION in visual art, the embodiment of ideas or concepts in human form.

PERSPECTIVE a scheme or formula for projecting an illusion of the three-dimensional world on a two-dimensional surface.

PIER an isolated vertical support of masonry, distinguished from a column by greater massiveness and generally by a cross-section other than circular.

PINNACLE small ornamental turret covered by a steep conical or pyramidal roof.

'PILGRIMAGE ROAD' CHURCH specific type of Romanesque church distinguished by a cruciform plan with continuous walkway around the nave, transept and choir; radiating chapels; galleries above the aisles opening into the nave or choir; and ribbed barrel vaults over the galleries.

PLAN the horizontal arrangement of the parts of a building or a drawing or diagram showing such an arrangement as a horizontal section.

POLYCHROMY many-coloured paint applied naturalistically to the surfaces of sculpture.

PROGRAMME in complex works of painting or sculpture, the underlying conceptual scheme determining the choice of subject matter or symbolism.

PSALTER a book containing the Psalms.

RELIEF SCULPTURE sculpture that is not freestanding, but is carved or cast so that it projects from a surface of which it is part.

RELIQUARY a small receptacle for a sacred relic, usually of a richly decorated precious material.

REPOUSSÉ formed in relief by beating a metal plate from the back, leaving the impression on the face. The metal is hammered into a hollow mould of wood or some other material and finished with a cutting tool called a graver.

RHYTHM in the visual arts, the regular repetition of a form.

RIB a projecting band of masonry, usually moulded, that forms part of the framework of a ribbed vault.

RIBBED VAULT a vault with a framework of arches or ribs connecting the supports.

ROSE WINDOW a large circular window filled with tracery and stained glass.

SCAFFOLDING a temporary structure for supporting one or more platforms by means of which workmen and their materials are brought within reach of their work.

SCRIPTORIUM a writing room; especially, a room in a monastery reserved for copying manuscripts.

SCULPTURE IN THE ROUND freestanding figures, carved or modelled in three dimensions (cf. RELIEF SCULPTURE).

SECTION in architecture, a diagram or representation of a part of a structure or building along an imaginary plane passing through it vertically.

SEVEN LIBERAL ARTS the group of seven sciences which formed the basis of secular education, especially in the early Middle Ages.

SHAFT slender column or half-column attached to a wall or pier, often acting as a subsidiary support for a vault or roof.

SHRINE place or object of veneration, often of a commemorative nature, and often a reliquary.

SOCLE in medieval architecture, the element directly below the base moulding of a pier.

SPANDREL the approximately triangular space of wall on either side of an arch.

SPIRE tall pyramidal or conical structure erected on a tower.

SPRINGING the lowest stone of an arch; the point or level at which an arch or vault begins to curve.

STAINED GLASS windows made of coloured glass fitted together with channelled lead strips soldered together, the whole installed in a bracing framework of iron.

STATUE-COLUMN a relief sculpture in which the support is a column.

STYLIZE to make conform to a given style; specifically, to design or represent according to the rules of a style rather than according to nature.

TEMPERA a painting medium in which pigment is mixed with egg thinned with water.

TEMPLATE a pattern used to indicate the shape that any piece of work is to assume when finished; a thin piece, cut to the profile outline of a member, to be used repeatedly as a guide in shaping many similar pieces, such as the voussoirs of a moulded rib.

THRUST the outward force exerted by an arch or vault; it must be counterbalanced by buttresses.

TRACERY branching ornamental stonework, generally in a window, where it supports the glass. There are two types, plate and bar tracery. *Plate tracery* is groups of openings pierced in solid masonry. *Bar tracery* means the subdivision of an opening by thin bars of stone, which often form intricate patterns.

TRANSEPT either of the lateral arms, at right angles to the main axis, in a church of cruciform plan.

TRANSVERSE ARCH arch at right angles to two walls or arcades, acting as a support for vault or roof.

TRIFORIUM a narrow, bandlike zone somewhere above the main arcade; often containing a longitudinal passage in the thickness of the walls.

TRIUMPHAL ARCH in Roman architecture, an ornamental version of a city gate placed in the middle of a city to permit entry of triumphal processions into its forum; in medieval basilicas, the western crossing arch.

TRUMEAU the post in the centre of a medieval portal.

TYMPANUM in Romanesque and Gothic architecture, the semicircular or pointed-arched surface above a church portal and within its enframing arch, often containing relief sculpture.

TYPOLOGY in medieval art, the practice of juxtaposing figures or scenes from the Old Testament with persons or scenes from the New Testament which the former were thought to prefigure.

VAULT a curved roof of masonry, constructed on the principle of the arch. See also BARREL, FAN, GROIN, NET, RIBBED VAULT.

VELLUM a fine kind of parchment, prepared from the inner section of the split skin of young animals, especially sheep or calves.

VOUSSOIR a wedge-shaped stone forming part of an arch.

WARP in weaving, the threads running lengthwise in the loom.

WEBBING the thin cover laid over the ribs of a ribbed vault.

WEFT in weaving, the yarns carried by the shuttle back and forth across the warp.

ZODIAC 'circle of animals' in Greek; an imaginary belt in the heavens extending for eight degrees on either side of the apparent path of the sun, divided into twelve parts of signs, each named for a different constellation. These signs of the zodiac are frequently represented in medieval art.

Further reading

GENERAL SURVEYS OF ART HISTORY

de la Croix, Horst and Tansey, Richard, *Gardner's Art Through the Ages*, 7th edn, Harcourt Brace Jovanovich, 1979

Janson, H. W. *History of Art*, Abrams/Thames & Hudson, 1977

Gombrich, Ernst. *The Story of Art*, Phaidon, 1978

Hartt, Frederick. *Art: A History of Painting, Sculpture, Architecture*, vol. I, Prentice-Hall, 1976

BACKGROUND ON MEDIEVAL HISTORY

The Metropolitan Museum of Art. *The Secular Spirit: Life and Art at the End of the Middle Ages*, 1975

Zarnecki, George. *The Monastic Achievement*, McGraw-Hill, 1972

Brooke, Christopher. *The Structure of Medieval Society*, McGraw-Hill, 1973

Martindale, Andrew. *The Rise of the Artist in the Middle Ages and Early Renaissance*, McGraw-Hill, 1972

INTRODUCTIONS TO MEDIEVAL ART HISTORY

Zarnecki, George. *Art of the Medieval World: Architecture, Sculpture, Painting, The Sacred Arts*, Prentice-Hall/Abrams, 1975

Focillon, Henri. *The Art of the West in the Middle Ages*, vol. 1 *Romanesque Art*; vol. 2 *Gothic Art*, Phaidon, 1969

Mâle, Emile. *Religious Art in France: The Twelfth Century*, Princeton University Press, 1978

Mâle, Emile. *The Gothic Image. Religious Art in France of the Thirteenth Century*, Harper & Row, 1958

Martindale, Andrew. *Gothic Art*, Thames & Hudson, 1967

Calkins, Robert. *Monuments of Medieval Art*, Dutton, 1979

Kraus, Henry. *The Living Theatre of Medieval Art*, University of Pennsylvania Press, 1967

ARCHITECTURE

Harvey, John. *The Master Builders: Architecture in the Middle Ages*, McGraw-Hill, 1972

Jacobs, David. *Master Builders of the Middle Ages*, Harper & Row, 1969

Branner, Robert. *Gothic Architecture*, Braziller, 1961

Branner, Robert. *Chartres Cathedral*, Norton, 1969

Saalman, Howard. *Medieval Cities*, Braziller, 1968

Stoddard, Whitney. *Monastery and Cathedral in France*, Harper & Row, 1972

Fitchen, John. *The Construction of Gothic Cathedrals: A Study of Medieval Vault Erection*, University of Chicago Press, 1961

Frankl, Paul. *Gothic Architecture*, Pelican, 1962

Two books on medieval architecture which, though intended for younger readers, are extremely clear and informative:

Macaulay, David. *Cathedral*, Collins, 1974

Macaulay, David. *Castle*, Collins, 1977

MEDIEVAL MANUSCRIPT PAINTING

Williams, John. *Early Spanish Manuscript Illumination*, Braziller, 1977

Avril, François. *Manuscript Painting at the Court of France: The Fourteenth Century*, Braziller, 1978

Robb, David. *The Art of the Illuminated Manuscript*, A. S. Barnes, 1973

MEDIEVAL PAINTING

Grabar, Andre and Nordenfalk, Carl. *Early Medieval Painting from the Fourth to the Eleventh Century*, Skira, 1957

Dupont, Jacques and Gnudi, Cesare, *Gothic Painting*, Skira, 1979

Demus, Otto. *Romanesque Mural Painting*, Thames & Hudson/Abrams, 1970

Index

Index

CAMBRIDGE INTRODUCTION TO THE HISTORY OF ART

The Middle Ages

Other titles in the series